POSTCARD HISTORY SERIES

Chicopee

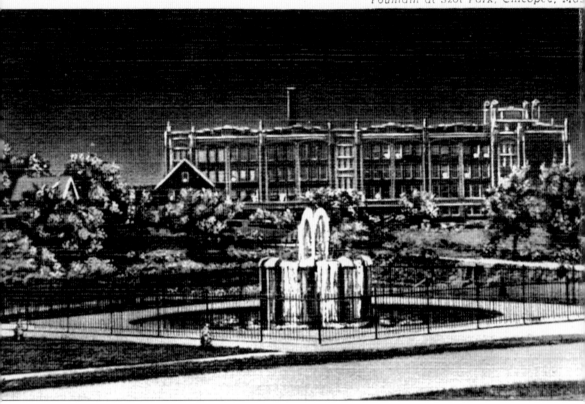

In January 1939, the New York World's Fair: Building the World of Tomorrow opened in Flushing, New York. The exhibition featured spectacular fountain light shows, which inspired Chicopee mayor Anthony J. Stonina to propose a light fountain for Chicopee's new Szot Park. The fountain would serve as a memorial honoring the Chicopee men who served in World War I. The cost for the entire project was set at $17,000 and was paid for by the Chicopee Electric Light Department. Chicopee's John Korkosz designed the electrical phase of the fountain. A rotating sequence of varying spray patterns are controlled by electrical operation and are coupled to a changing pattern of multicolored floodlighting that plays through the shimmering water sprays.

POSTCARD HISTORY SERIES

Chicopee

Stephen R. Jendrysik

ARCADIA

Copyright © 2005 by Stephen R. Jendrysik
ISBN 0-7385-3727-6

First published 2005

Published by Arcadia Publishing,
Charleston SC, Chicago IL, Portsmouth NH, San Francisco CA

Printed in Great Britain

Library of Congress Catalog Card Number: 2004113721

For all general information, contact Arcadia Publishing:
Telephone 843-853-2070
Fax 843-853-0044
E-mail sales@arcadiapublishing.com
For customer service and orders:
Toll-free 1-888-313-2665

Visit us on the Internet at www.arcadiapublishing.com

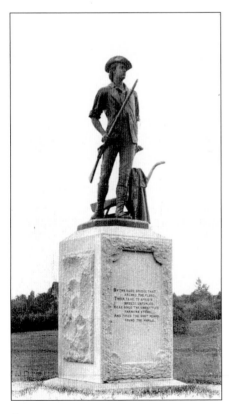

In November 1873, Ebenezer Rockwood Hoar, the representative from Concord in the 43rd U.S. Congress, persuaded the body to make a gift of 10 surplus brass cannons to the town of Concord. The cannons were shipped to the Ames Foundry in Chicopee, where 23-year-old sculptor Daniel Chester French, working with Chicopee's Silas and Melzar Mosman, transformed the discarded cannons into the *Concord Minuteman*. On the nation's 100th birthday, the statue was unveiled by Ulysses S. Grant at Concord Bridge before a crowd of 50,000 people. From that day forward, Concord's citizen soldier symbolized American freedom.

CONTENTS

ACKNOWLEDGMENTS

In the limited realm of community history, the creation of a second volume of historic photographs is a truly complex challenge. This is especially true because Michele Plourde-Barker's *Chicopee*, published in 1998, was a scholarly, well-written, and truly comprehensive pocket history of the city. My decision to write a postcard history book was prompted by an opportunity to view the private collection of Chester Kobierski, a longtime member of the Chicopee Historical Society who had made his collection of historic photographs a major part of the first Chicopee volume. The Kobierski collection, combined with postcards from the Edward Bellamy Memorial Association, the Chicopee Historical Society, and the Chicopee Public Library, provided an adequate supply of unique images.

I have written this book in response to the urgings of the wonderful people who read my weekly column in the *Springfield Republican*. This project was made possible by the help and support of Chester and Alison Kobierski, Joseph Pasternak Jr., and Michael Baron, and by the technical assistance of Dr. John Kozikowski.

Most importantly, I want to thank my best friend and life partner, my wife, Barbara, for her forbearance and for her encouragement of her husband's lifetime obsession with the history of Chicopee.

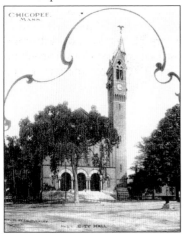

The Chicopee City Hall, designed by Charles B. Parker of Boston and built in 1871, remains the community's most prominent structure. The imposing clock tower, with its spectacular bronze eagle weather vane, is Chicopee's most recognizable landmark. Over the years, it has served as the city's unofficial logo in countless publications. The clock was designed and built by the E. Howard Watch and Clock Company of Boston. The historic eagle weather vane was cast by the city's legendary Ames Sword Company.

INTRODUCTION

Chicopee lies in Hampden County, halfway between Boston and Albany. The city encompasses 25.7 square miles. It is bounded on the north by Holyoke, on the northeast by South Hadley and Granby, on the east by Ludlow, on the south by Springfield, and on the west by the Connecticut River. The river that runs through it is called the Chicopee River.

The highest point in the city is near the Jewish Cemetery on upper Pendleton Avenue, and the lowest point is near the Buxton plant on Plainfield Street, on the Springfield city line. According to Chicopee historian Bessie Warner Kerr, the Pendleton Street site is 245 feet above sea level, the Plainfield Street site is 63 feet above sea level, and the average height above sea level in the city is 154 feet. Kerr also notes that the city contains much sand and gravel; only 20 percent of the land is fit for cultivation. Nonetheless, the region's first settlers were farmers.

In 1636, Puritan William Pynchon led a small group of settlers from Boston. They established the first settlement as an outpost on the Agawam meadows on the west side of the Connecticut River. Local legend had the settlement of the Chicopee meadows two years later; however, Pynchon didn't buy Chicopee land from the Nipmucks until 1641. The first settlers used the northern part of Springfield as a pasture for their livestock. Early geological maps show meadows and flats along the banks of the two rivers that were used as grazing land for cattle and swine.

Two hundred years later, that all changed when the potential sites for waterpower on the Chicopee River attracted the attention of outside capitalists. The town did not grow into an industrial community; it suddenly found that it was one when industrial developers dammed the river at two sites and built their factories. For the most part, this book of early-20th-century postcards is the story of the two separate mill towns that were created: Factory Village and Cabotville.

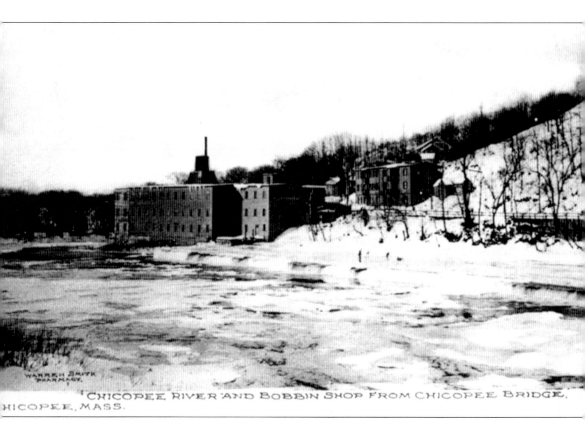

"CHICOPEE RIVER AND BOBBIN SHOP FROM CHICOPEE BRIDGE,
HICOPEE, MASS.

The "Old Indian Wading Place" is shown in the winter scene on this postcard, which is postmarked July 14, 1903. The postcard, captioned "Chicopee River and Bobbin Shop from Chicopee Bridge," was purchased at Warren Smith's Pharmacy on Exchange Street. The Dana S. Courtney Bobbin Shop remained in business until the 1950s. Prior to the construction of a covered bridge in 1783, both Puritans and Native Americans forded the Chicopee River here. The first grant of land in Chicopee, in 1659, consisted of "One farme given to Mr. John Pyncheon, lying over the Chicuppy river, with the islands of said river below the place called the wading place."

One

THE FOUNDERS
OF CHICOPEE

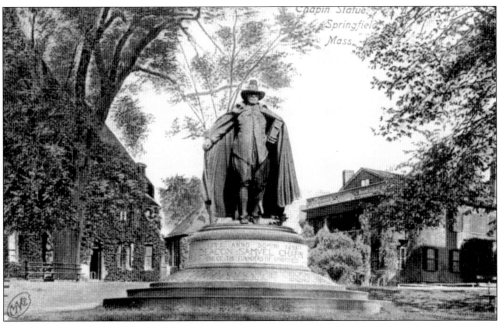

The Puritan, the statue by Augustus Saint-Gaudens representing Dea. Samuel Chapin, is shown in its original Springfield setting of Stearns Square. In 1675, Chapin died in his son's home on Chicopee Street. He left 7 children and 72 grandchildren. Most historians agree that the first homes in Cabotville were built by Chapin's sons Henry and Japhet.

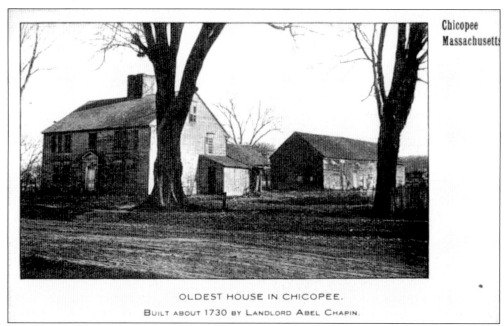

OLDEST HOUSE IN CHICOPEE.
BUILT ABOUT 1730 BY LANDLORD ABEL CHAPIN.

The Chapins were the dominant landowners along the Connecticut River for most of the 1600s and 1700s. The Abel Chapin House, pictured in this early-20-century postcard, is still standing at the corner of Clarendon Avenue and Chicopee Street. The old farmhouse, built in 1730, is the city's oldest structure.

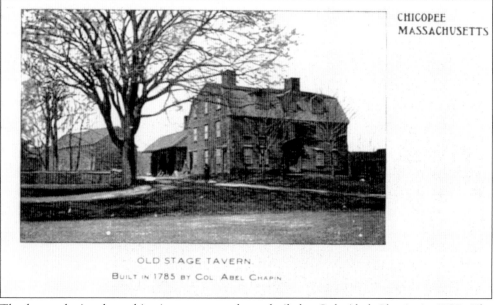

OLD STAGE TAVERN.
BUILT IN 1785 BY COL. ABEL CHAPIN

The house depicted on this vintage postcard was built by Col. Abel Chapin in 1785. The building served for many years as the Old Stage Tavern on Chicopee Street. Chapin was a farmer who fatted cattle for the Brighton and New York markets. His son, Sumner, continued the tavern and the fattening of cattle. Both father and son were famous for always winning the blue ribbon at area cattle shows. The building was demolished when radio station WACE was constructed.

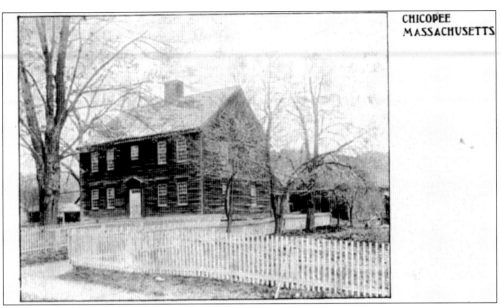

The Zerah Chapin House was built on lower Chicopee Street in 1893. The handsome Georgian Colonial structure was dominated by its huge gable roof and immense central chimney and was distinguished by its handsome door frame. Some original glass and an abundance of interior detailing saved the home from demolition in 1973, when the Chapin home was in the path of construction for Interstate 391. The house was carefully dismantled and shipped to Connecticut, where it was painstakingly restored.

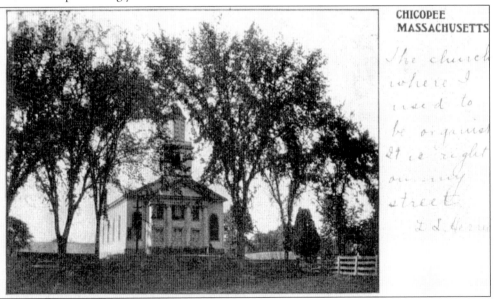

In 1751, the residents of Chicopee Street built their own meetinghouse and formed their own parish, the Fifth Parish of Springfield. They chose Ens. Benjamin Chapin as the first parish moderator and Rev. John McKinstry as the first minister. In 1825, the original meetinghouse was replaced with a new church. This structure, built in the Federal style, was taken from a design first published by architect Asher Benjamin in his *Country Builder's Assistant* in 1797. Today, the First Congregational Church is the oldest church building in Chicopee.

11

In this early-20th-century view of the Chicopee River near the Springfield city line, the picturesque scene looks very much like a rural country stream. However, rivers like the Chicopee have long defined the core of Massachusetts's urban areas. The harnessing of these rivers for power and manufacturing characterized the Commonwealth's growth in the 19th century as a center for commerce and prosperity.

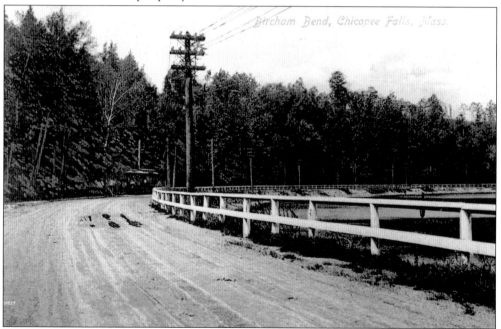

This view of the historic "Upper Chickopee River" at Bircham Bend features the Springfield Street Railway's trolley to Indian Orchard. For years, the spring established by the Nipmuck Indians at the bend in the river provided a refreshing rest stop for travelers.

Two

FACTORY VILLAGE

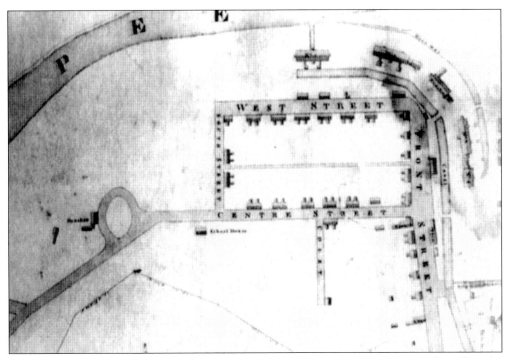

In 1825, the Chicopee Manufacturing Company built its first mill in Chicopee Falls. When the Alex Wadsworth Company of Boston drew this plan in 1834, the complex included four textile mills, a bleachery, a store, and two dozen boardinghouses for mill workers.

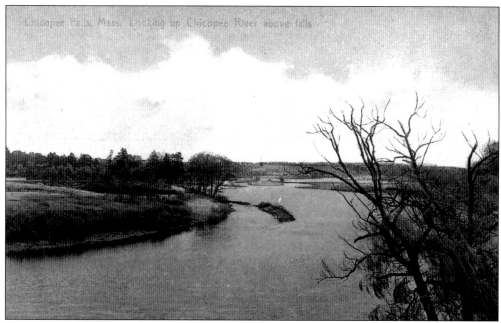

The first settlement on the upper Chicopee River was made in 1660 at Skipmuck, located about a mile above the falls. Most of the settlement was on the south side of the river. In this postcard of "Old Skipmuck," the Poor Brook flows into the river at the Oxford. The settlers cultivated the large tracts of silt-rich topsoil along lower East Main Street.

At the left side of this eastward view of the Chicopee River is the boat launch area at the foot of Taylor Street. In recent years, the continued improvement of water quality has led to better river access and expanded public use.

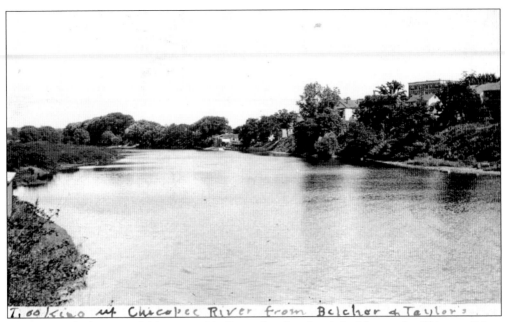

Looking up Chicopee River from Belcher & Taylor's

The note at the bottom of this postcard indicates that the view is looking up the Chicopee River from the Belcher & Taylor Agricultural Tool Factory. The scene is the man-made lake that formed behind the Chicopee Falls dam.

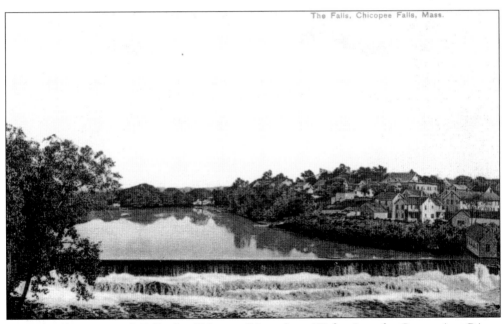

The Falls, Chicopee Falls, Mass.

From the Skenungonuck Falls, the Chicopee River drops 77 feet into the Connecticut River. The first dam built behind the falls was a single row of logs about one foot high. It was followed by a two-foot-high dam, and in 1825, by a seven-foot-high log dam.

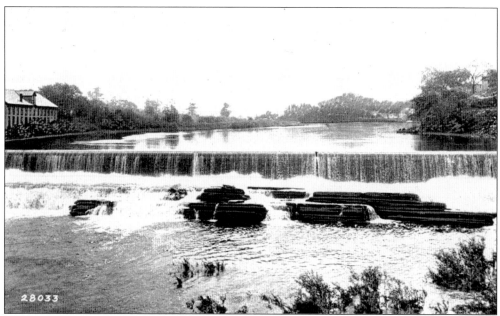

This factory, erected by David Ames in 1827, employed over 100 girls and several men. It was one of five paper mills owned by the Ames family. David Ames's brother, John L. Ames, invented the first rotary papermaking method used in the United States. The Ames companies were making over one half of the paper used in this country in the 1830s.

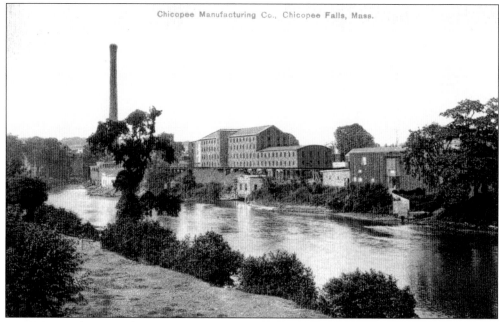

In 1822, Jonathan Dwight purchased the water privilege and a large tract of land in Chicopee Falls. Pictured here is the first large-scale textile mill constructed on the Chicopee River. By 1827, the Chicopee Manufacturing Company had two four-story brick factories containing 7,000 spindles and 240 looms. With the completion of a third mill, the company had about 14,000 spindles and nearly 500 looms, making the operation the second largest in Massachusetts.

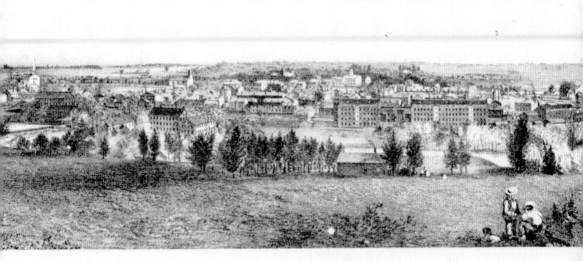

CHICOPEE FALLS, MASS. 1857.

NO. 36 PUB. BY J. C. BUCKLEY

In 1932, the Council of Industrial Studies at Smith College published the book *Economic History of a Factory Town*, by Vera Shalakman. In her book, Shalakman traced the transformation of the rural village of Chicopee into a factory town.

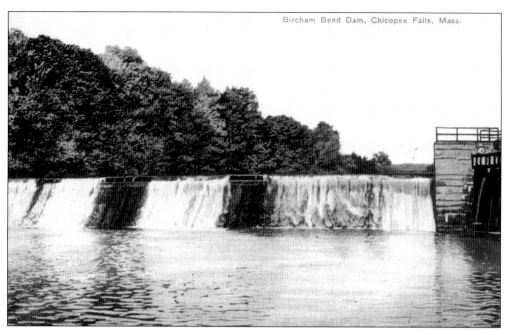

Bircham Bend Dam, Chicopee Falls, Mass.

In 1836, a new eight-foot-high timber dam was built at the falls. It was not replaced until the summer of 1894, when, according to local legend, an unusually dry summer allowed the contractors to move at a rapid pace. The old structure was removed by June 5, and the construction of a brand-new stone dam was completed by August 8.

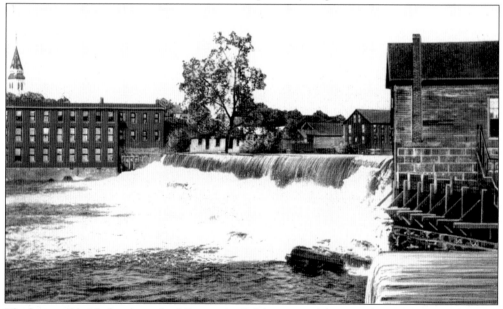

The large red brick factory at the falls was the Belcher & Taylor Agricultural Tool Company. In 1852, Bildad P. Belcher examined a new invention from Vermont that the inventor called the Yankee blade. Belcher's company purchased the rights to the blade, calling it a self-sharpening feed cutter. The blade used a reverse motion, and the application of oil and emery performed the sharpening operation. In 1861, Belcher's business had so increased that he expanded and joined in partnership with George S. Taylor.

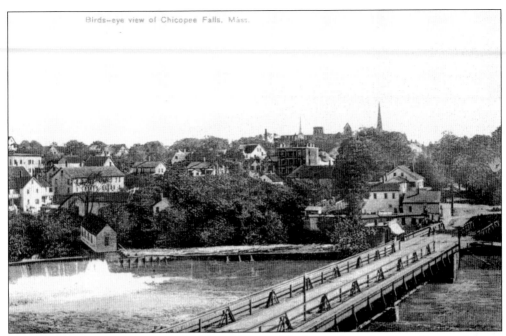

This rare panoramic color postcard of the Chicopee Falls dam and canal spillway features the new open steel bridge, constructed in 1905. The bridge, which replaced the old covered bridge, served until it was washed away by the fierce hurricane of 1938.

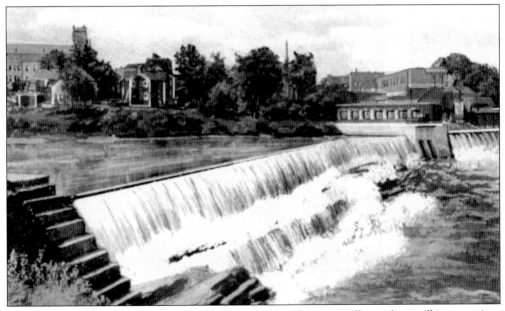

In this 1920s postcard, the gatehouse, the dam, and the Chicopee Falls canal are still in operation. In 1944, the Johnson and Johnson Company (Chicopee Manufacturing Company) informed the city it that could no longer maintain the facilities. The city reluctantly agreed and eventually filled in the canal.

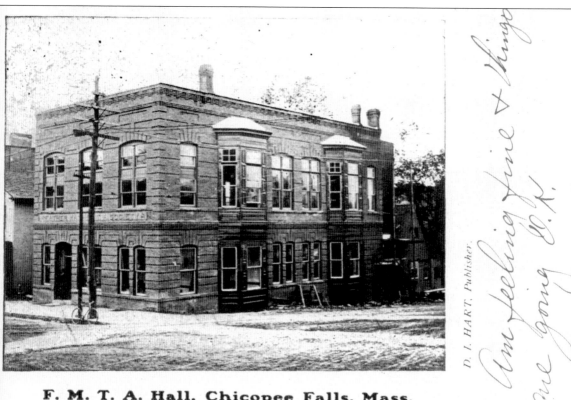

D. I. HART, Publisher.

F. M. T. A. Hall, Chicopee Falls, Mass,

The argument over the use of alcoholic beverages has plagued the Pioneer Valley since the early days of settlement. The most prominent temperance organization for many years was headquartered in Chicopee Falls. In 1901, the Father Mathew Total Abstinence Mutual Benevolent Society completed the construction of a handsome building on the corner of Main and Bridge Streets. The structure, designed for the society's use only, had a bowling alley in the basement. The second floor was divided into elegantly furnished parlors, a reading room, a billiard hall, and a meeting room. On the top floor was one of the largest halls in the city, which was used for meetings and social events.

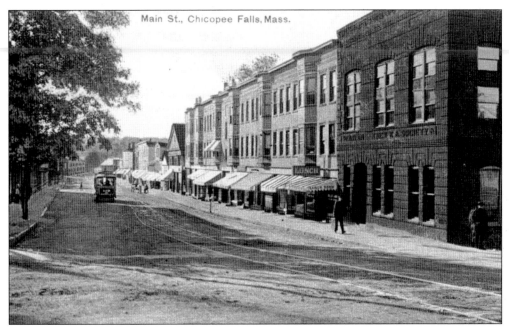

This view of the intersection of Main Street and Bridge Street (Broadway) was taken before the Chicopee Electric Light Company installed poles and street lamps. On the far right is the headquarters of the Father Matthew Total Abstinence Society, constructed in 1901.

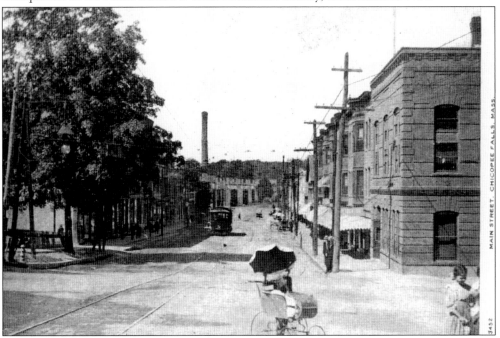

The switch for the first streetlights was thrown on May 28, 1896. There were 118 direct-current arc lights and 28 alternating-current incandescent lamps glowing on the city's principal streets. Some 400 poles, stout trees, and building corners supported the electric wires. The lights on Main Street were on the "moonlight schedule," which meant that on bright nights the lamps were not turned on.

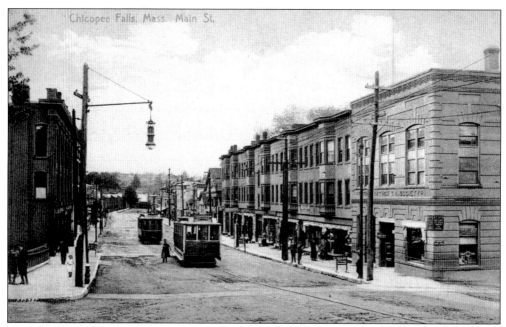

This postcard shows a view of Main Street, looking west, sometime before 1910. In those days, the street was a mixture of early-19th-century wooden homes and a growing number of larger brick commercial buildings.

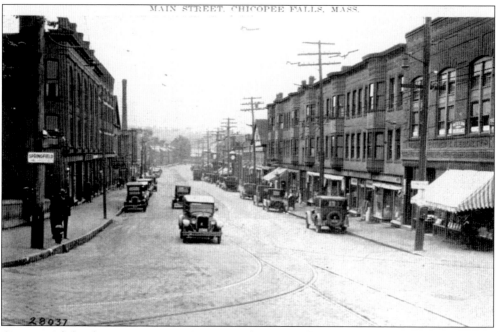

Commercial development on Main Street in Chicopee Falls peaked in the 1920s. During the next decade, Williams Market and the Professional Building burned to the ground in two spectacular fires. In the 1970s, Chicopee's urban renewal project demolished the majority of the buildings in the old business district.

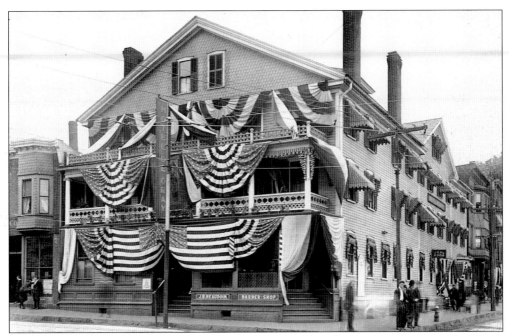

In 1886, Joseph H. DeGray purchased the Wiles Hotel, on the corner of Main and Church Streets, and immediately began to remodel and enlarge the facility. In this 1905 postcard, the building is festooned for the community's Fourth of July celebration. For over 30 years, the Hotel DeGray was the most popular address in Chicopee Falls.

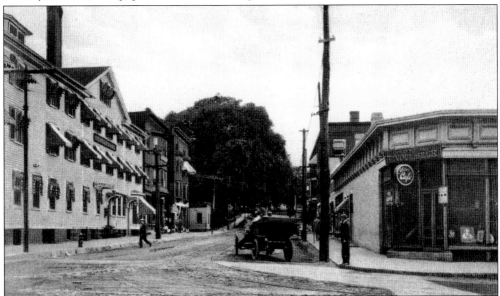

This postcard view of the intersection of Church and Main Streets highlights the rear of the Hotel DeGray. In 1890, Joseph DeGray purchased the adjacent Opera House of Chicopee Falls. He had the opera house repainted, enlarged, redecorated, and joined to the hotel by the addition of a brick wing. Adjoining the opera house, DeGray constructed a handsome three-story building that fronted Church Street. The first floor was occupied by the post office. In the lower floor of the opera house was an American Express office, a meat market, and a grocery store.

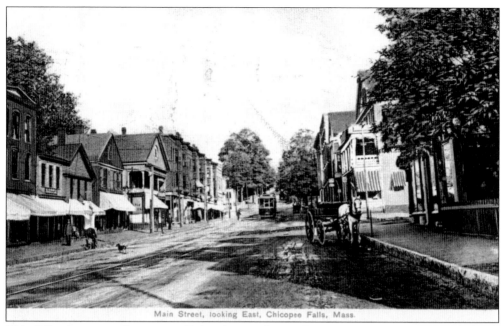

Main Street, looking East, Chicopee Falls, Mass.

This full-color postcard captures all the charm of a small town at the beginning of the 20th century. The Hotel DeGray, with its distinctive awnings, is on the right, just behind the horse and carriage.

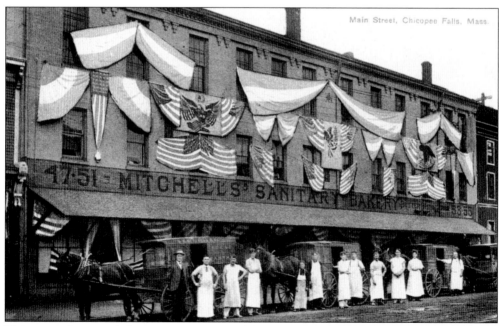

Main Street, Chicopee Falls, Mass.

This unusual postcard features a very successful turn-of-the-century Main Street business. In 1911, there were 10 bakeries in Chicopee. L. H. Mitchell operated the city's largest fleet of delivery wagons. Issued for the Fourth of July, the card is titled "Bread Wagon Train."

In the early 20th century, firefighters were popular postcard subjects. According to local historian Bessie Warner Kerr, a fire district was organized as early as 1848. The purchase of fire equipment for the volunteer force was funded by contributions from manufacturing companies. For the next 45 years, the fire department was privately funded. In 1893, the city created the municipal fire department, which was professionally staffed and publicly funded. The first modern station was constructed on the corner of Church and Market Streets. The fire bell tower at the rear of the building was the tallest structure in Chicopee Falls.

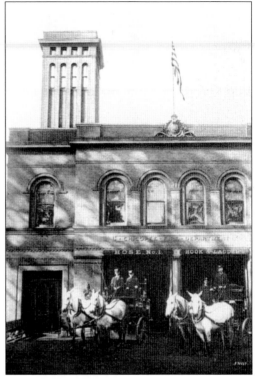

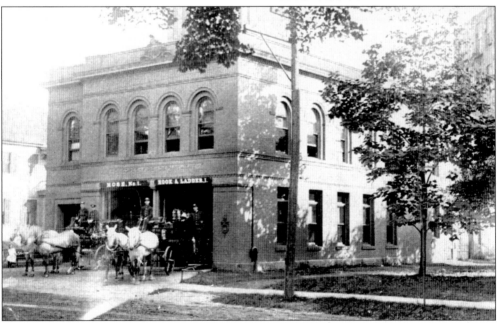

This postcard shows the well-landscaped grounds of the firehouse. In Chicopee Falls, Hose Company No. 1 and Hook & Ladder Company No. 1 pose proudly with their horse-drawn apparatus. Within a few years, the fire company was fully mechanized with two brand-new Knox fire trucks purchased from the famous Springfield Company. The Chicopee Falls Station was demolished in 1977, when the new safety complex on Church Street was built.

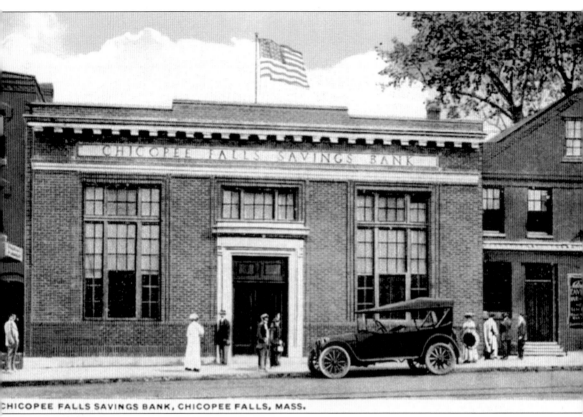

CHICOPEE FALLS SAVINGS BANK, CHICOPEE FALLS, MASS.

The Chicopee Falls Savings Bank was chartered on March 20, 1875. The building on Main Street survived the urban renewal project of the 1970s and remains a Chicopee Falls landmark.

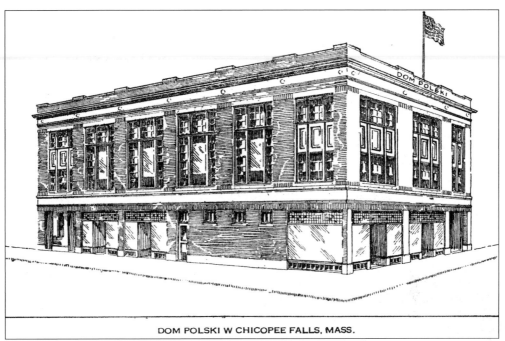

DOM POLSKI W CHICOPEE FALLS, MASS.

The Polish National Home on Grove Street was built to provide citizenship education for immigrant Poles while helping them retain their cultural identity. According to the 1915 city directory, there were 20 Polish associations in the city.

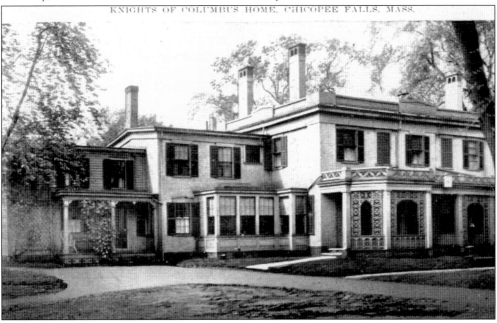

This house was designed by Elias Carter in 1836–1837 at Church and Grove Streets. The home was turned over to his newly married son, Timothy W. Carter, and bride. Timothy Carter became a successful businessman and civic leader. His daughter, Mary Carter, was the last family member to reside in the home. Following her death in 1923, the estate was acquired by the Chicopee Falls Elder Council of the Knights of Columbus.

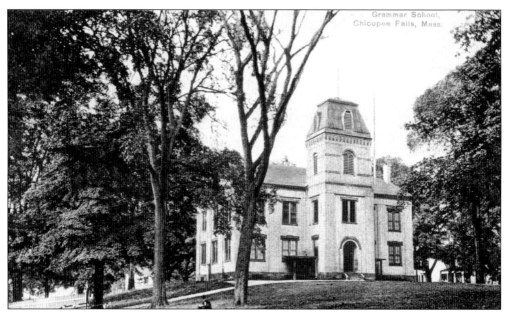

The postcard's title refers to this handsome brick Italianate building as the grammar school in Chicopee Falls. Actually, the building, constructed in 1845 on the hill at the corner of Church and Grove Streets, served as the Falls High School for 45 years. In those days, the town maintained two first-class high schools; the other school was on Grape Street in Chicopee Center.

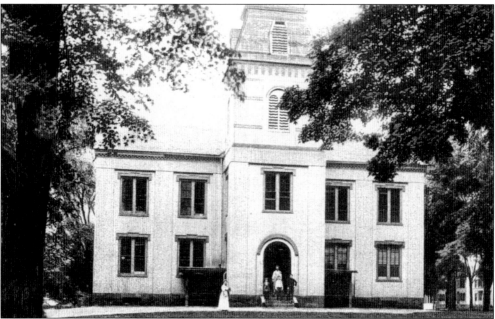

This postcard provides a closeup view of the classic architecture of the Church Street School. In 1890, the newly minted city opened a new state-of-the-art central high school on Front Street. The old school served as the neighborhood grammar school until World War II, when the building served as Chicopee's USO headquarters. Following the war, the building served for many years as the Chicopee Falls Community Center.

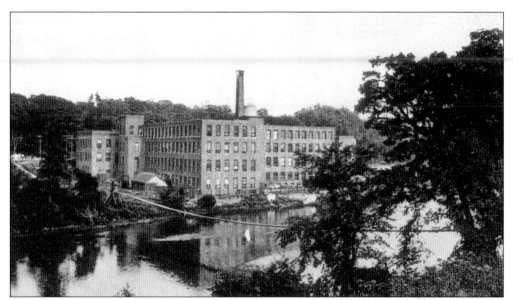

This 1905 postcard features the pedestrian suspension bridge over the Chicopee River. The bridge provided workers from Granby Road with a shortcut to their jobs in Chicopee Falls. The building in the foreground is the Fisk Rubber Company. In 1898, the Spaulding and Pepper Company of Chicopee sold out to Noyes W. Fisk of Springfield. The company was renamed the Fisk Rubber Company and continued the manufacture of bicycle tires and a wide range of household rubber goods and industrial cleaning products.

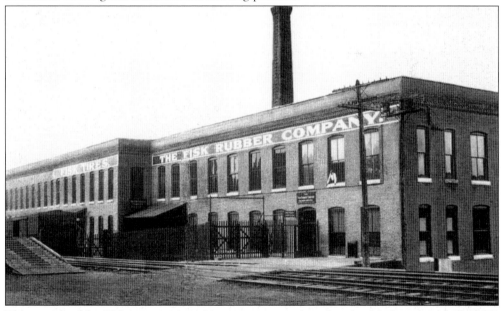

The growth of the 20th-century-American economy was keyed to the development of affordable transportation. In nearby Springfield, the Duryea brothers were making automobiles. The Knox Company was manufacturing fire trucks, and George Hendee had just introduced his famous Indian motorcycles. This Fisk building, adjacent to the railroad tracks, served as the company offices and the bicycle tire division. In 1901, as the bicycle industry collapsed, Fisk introduced a full line of motor vehicle tires.

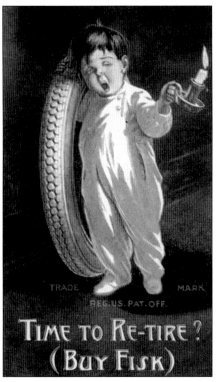

TIME TO RE-TIRE?
(BUY FISK)

With an early-1900s automobile tire wrapped around his right arm and a candle in his left hand, this pajama–clad little man became one of the most recognizable American industrial trademarks. In business, timing is everything. In 1902, a year after its inception, Fisk's automobile tire division eclipsed all the other departments. The little company at the bend in the Chicopee River was in position to be a major player in the development of the automobile industry.

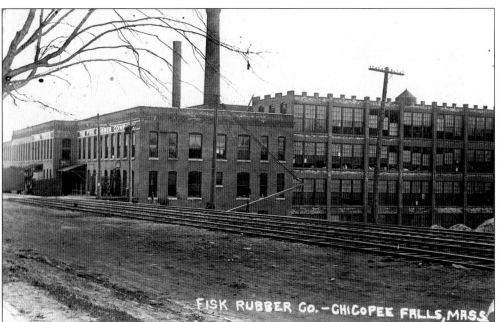

FISK RUBBER CO.—CHICOPEE FALLS, MASS.

In 1904, extensive additions had been completed, and the employees in the parts division were working double shifts to keep up with the demand for tires. The company's board of directors had convinced local bankers to advance considerable sums of money for an extensive plant-expansion program. The orders were coming in from the largest companies in the automobile industry. By 1910, Fisk was employing 600 people at its Grove Street plant.

In this 1911 postcard, the Fisk Company introduced a delightful variation on its famous trademark. The attractive young woman was part of a new national advertising campaign for Fisk's newly expanded retail division. By 1912, the number employed in Chicopee Falls had increased to over 2,000, making the company Chicopee's largest employer.

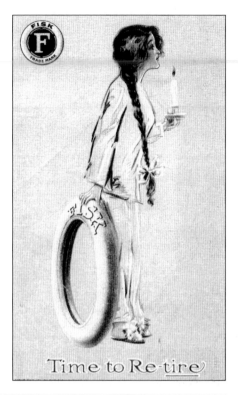

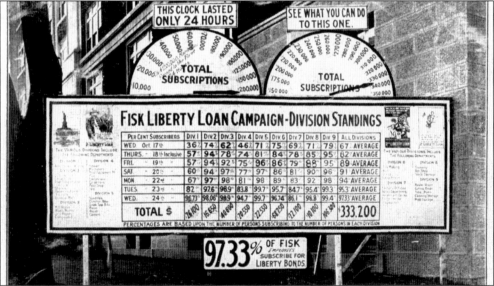

At about that same time, the Fisk Company introduced the heavy Town Car Tread tire. It was advertised as a positive nonskid tire, providing the protection on wet pavements and slippery streets that every motorist was looking for. In 1915, as war raged in Europe, the company became a major supplier of military vehicle tires. Employment reached 3,000, and the weekly payroll averaged $48,000. The plant was again undergoing major expansion with the construction of additional buildings. This postcard indicates that when America entered the war, Fisk workers led the community in support of the Liberty Loan bond drives.

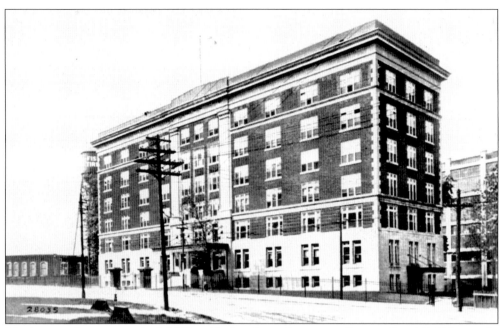

Wartime employment reached 4,500, with the Grove Street payroll exceeding $70,000 a week. By 1918, the complex had 28 buildings with over 30 acres of floor space. Featured in this postcard is the most impressive structure, the new seven-story administration building. Designed by George B. Allen and constructed by the Fred T. Ley Company of Springfield, the building remains one of the city's most imposing landmarks.

The Fisk Company survived the rocky postwar years by expanding its retail store operations to 40 states. In the 1920s, the Red Top tire line was the best-selling passenger car tire in the United States. The company still built tires for the major automobile makers, but it increasingly directed its efforts toward the over-the-counter retail market.

32

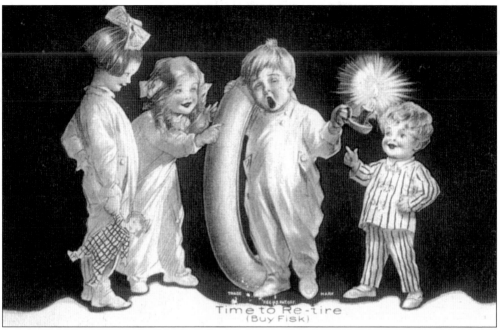

Time to Re-tire
(Buy Fisk)

The company franchised Fisk tire dealers in gas stations and automobile repair shops and operated its own Fisk retail tire stores in 40 states. Fierce competition led the company to offer premiums to entice car owners to "re-tire" with Fisk tires. The free premiums always featured the company's famous trademark logo. The purchase of a full set of four tires qualified you for a handsome lamp or mirror. These were quality items exhibiting the images of the yawning pajama-clad youngster and his friends.

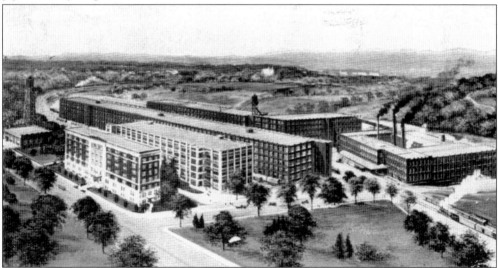

This full-color 1920s postcard captured the state-of-the-art facility during the company's most successful period. The sparkling new buildings created the best working conditions in the rubber industry. Designed for maximum light and ventilation, the complex housed a private emergency hospital with a doctor and nurse on duty at all times, a modern cafeteria, and employee recreation and reading areas. The "Fiskers" were the first in the area to be afforded the eight-hour work day. The Chicopee River plant was turning out 5,000 tires a day.

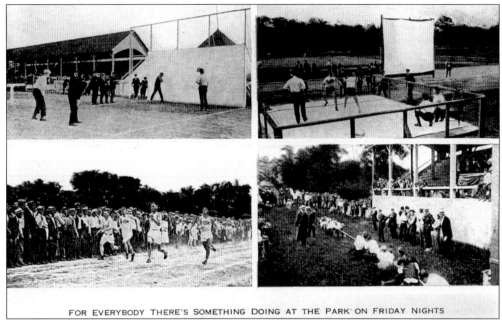

FOR EVERYBODY THERE'S SOMETHING DOING AT THE PARK ON FRIDAY NIGHTS

The Fisk Athletic and Social Association was organized in 1921, the same year the company closed the recreation department. The new organization took over the management of Fisk Park, a 40-acre facility located at the top of the hill between Liberty Street and St. James Avenue. This postcard says there is something for everyone at Fisk Park.

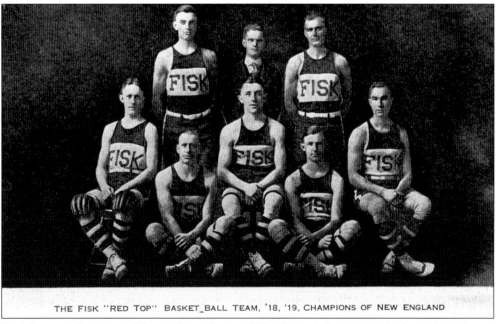

THE FISK "RED TOP" BASKET_BALL TEAM, '18, '19, CHAMPIONS OF NEW ENGLAND

Red Top was the name of the top line of tires sold by the Fisk Company. As shown here, it was also the name of the company's athletic teams. The teams competed in the A division of the New England Industrial League, and they won many championships. The company's hiring policy included recruiting outstanding local athletes.

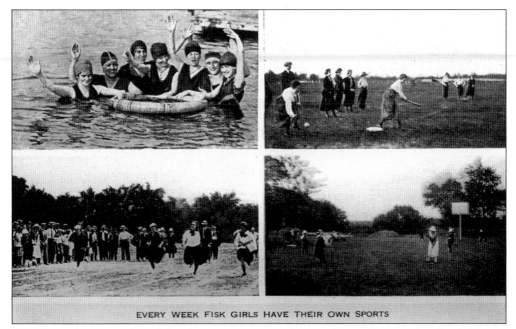

EVERY WEEK FISK GIRLS HAVE THEIR OWN SPORTS

All Fisk employees, male and female, were encouraged to participate in recreational activities on a weekly basis. They automatically became members of the athletic and social association and were eligible to take part in any function it hosted.

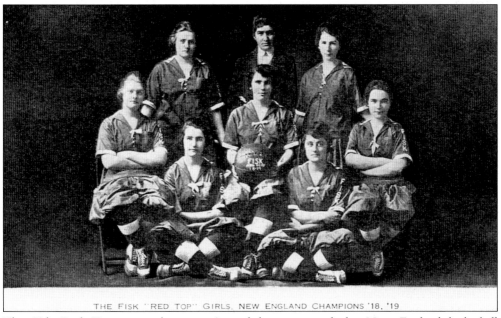

THE FISK "RED TOP" GIRLS, NEW ENGLAND CHAMPIONS '18, '19

The Fisk Red Top women's team pictured here captured the New England basketball championships in 1919. The company publication, the *Fisk Candle*, reported that there was a female team in every sport except hardball and hockey.

Chicopee Falls, originally known by its Native American name of Skenungonuck Falls, is shown in this 1905 postcard. Looking southeast, the image shows the homes on Canterbury and East Main Streets. In 1823, the Boston and Springfield Manufacturing Company dammed the river at this point to take advantage of the natural drop in the terrain.

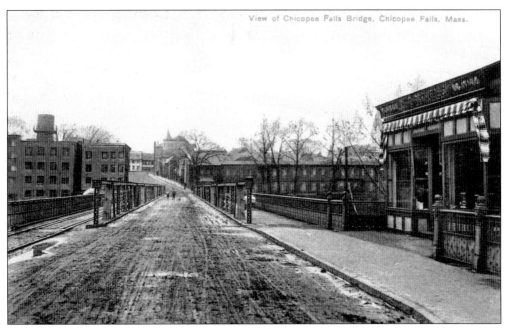

On the north side of the falls, Elder Hiram Munger, a millwright, built a waterwheel and established a gristmill. The building on the left side of the bridge was the original site of Munger's gristmill. In 1864, Joshua Stevens bought the mill and there, at the foot of Montgomery Street, set up a small shop making arms and mechanics' tools.

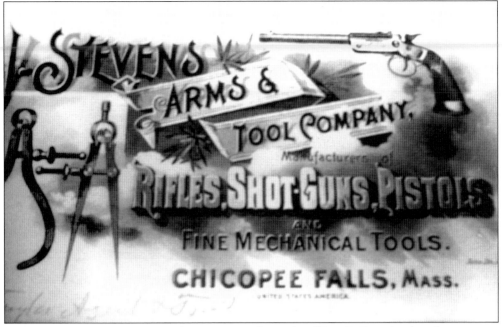

Joshua Stevens, in partnership with James E. Taylor and William B. Fay, developed a company with a worldwide reputation for rifle barrels with uncanny precision. All the sharpshooters in Buffalo Bill's Wild West Show endorsed Joshua Stevens's incomparable .22 Long rifle.

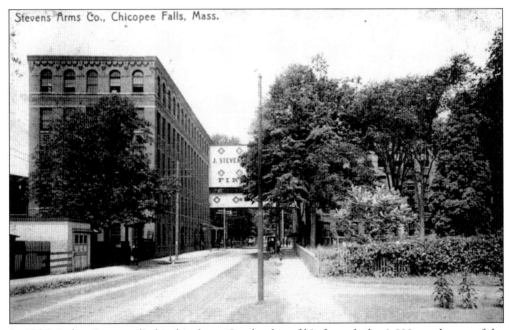

In 1907, Joshua Stevens died in his sleep. On the day of his funeral, the 1,000 employees of the J. Stevens Arms and Tool Company observed a moment of silence in the cavernous 12.5-acre Hill Plant on Broadway. That year, the factory turned out 1,000 rifles and shotguns every day.

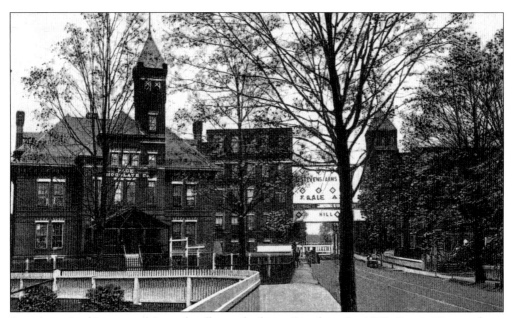

Prominent in this postcard is a schoolhouse built on Broadway in 1875. Some 12 years later, A. H. Overman built a bicycle factory next-door. The noise from the factory truly undermined the effective administration of the school. In 1893, at the height of the national bicycle craze, Overman bought the school and converted it to needed factory space.

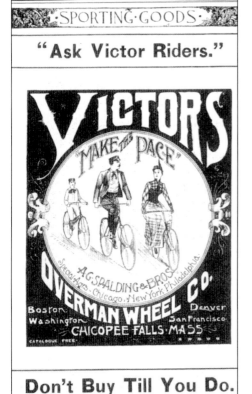

The demand for bicycles reached its peak in 1894. Overman employed more than 1,200 people and was hard-pressed to meet the demand for Victor bicycles. Quoted frequently in the national press, Overman boasted, "Our factory is the only bicycle plant in the world where the complete bicycle is made from handlebars to tire. We claim that it costs more to build a Victor Bicycle than any other bicycle on earth."

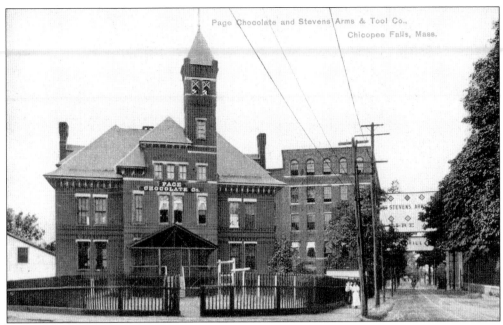

For 18 years, from 1883 to 1901, Albert H. Overman and his world-famous Victor bicycle put Chicopee Falls on the national industrial map. Enormous expansion in the bicycle industry in 1895 and 1896, combined with brutal competition and price cutting, destroyed the Overman Wheel Company. By 1901, the old Victorian schoolhouse was a chocolate factory, and the Stevens Company was making firearms on Broadway.

This bleak scene is perhaps appropriate. While the Spanish-American War in 1898 had boosted weapons sales, in the inevitable postwar letdown, the Stevens Company found itself with excess manufacturing equipment and buildings. Flush with the war profits, a skilled labor force, and available factory space, the company was ripe for a new venture.

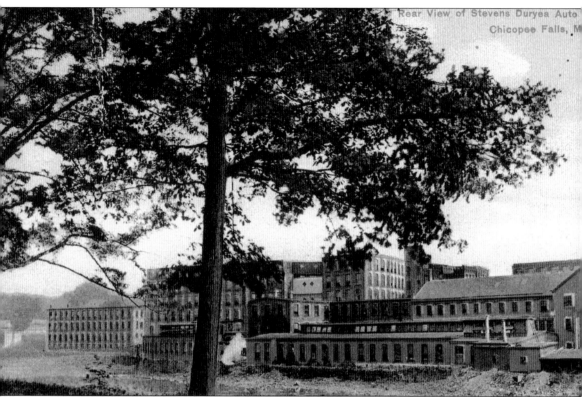

Chicopee industrialist Irving H. Page was the majority stockholder in the Stevens Arms Company. In 1901, he and his board of directors were seeking to invest in some potentially profitable business or industrial venture. The corporation owned two extensive factory groupings: the Hill Plant on Broadway and a large factory complex on the Chicopee River. The manufacturing floor of the river plant, pictured here, was soon converted into an automobile factory.

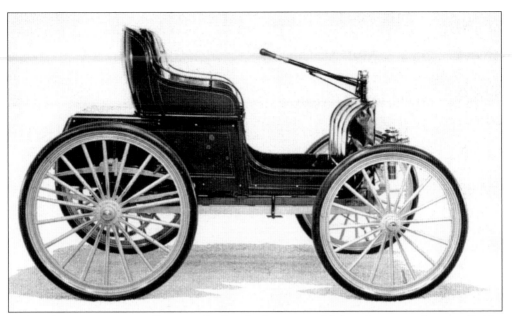

Today, the Duryea is generally recognized as the first successful American car to be propelled by an internal combustion engine. The first motorized buggy assembled by Charles E. and J. Frank Duryea in their Springfield machine shop was road-tested in 1893. The car pictured here was one of the 13 vehicles in the first production run in America in 1896. The Duryea Wagon Company was the first motorcar corporation in the United States.

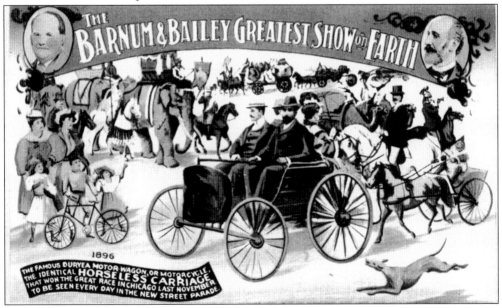

This reproduction of an 1896 Barnum & Bailey Circus postcard announces that the horseless carriage that won America's first automobile race in Chicago on November 28, 1895, would appear in the circus parade every day. A Duryea car won the second car race in New York City and won Europe's first race in Brighton, England. In September 1896, a Duryea car also won at the world's first racetrack in Providence, Rhode Island. The Duryeas all won the prizes for gasoline cars.

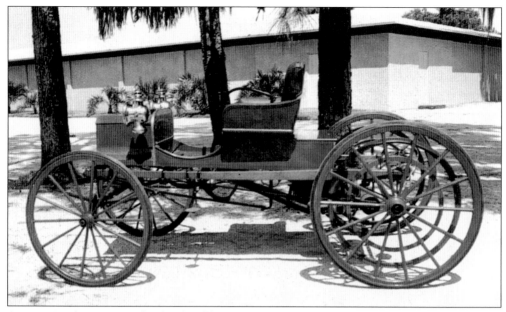

Automotive historian Richard Scharchburg writes that "it was J. Frank Duryea who did the actual construction on the cars and was responsible for practical designing and engineering all components of the Duryea Cars." For this 1897 model, Duryea designed and built the four-cycle water-cooled motor, the first of its kind. The car included an electric ignition, a spray carburetor, a governor, a muffler, and a hand-cranking device.

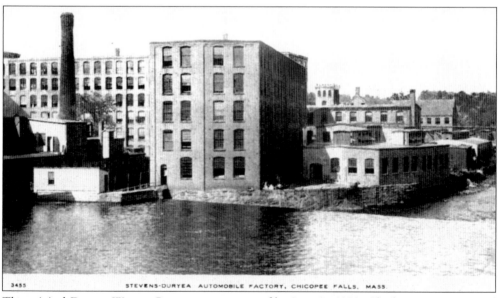

The original Duryea Wagon Company went out of business in 1898. Charles Duryea returned to the Midwest, and his younger brother, Frank, stayed in the Springfield area. Two years later, J. Frank Duryea was back in the automobile business with a new partner, Irving Page. The Stevens Arms Company began the conversion of the river plant in 1903, and a shiny new nameplate appeared on the road. The day the Stevens-Duryea Company was born, Page told his new partner he wanted him to make the best cars in America.

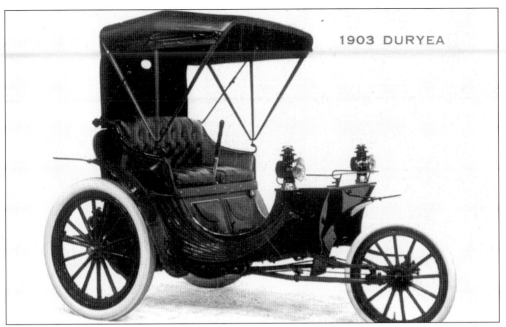

1903 DURYEA

In 1903, J. Frank Duryea was given creative control of manufacturing. One of the company's first cars featured a revolutionary three-wheel design, with framework supporting a rear engine, a transmission, and a front axle that allowed the vehicle to pivot.

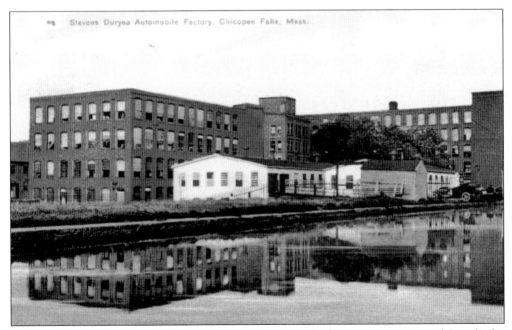

Stevens Duryea Automobile Factory, Chicopee Falls, Mass.

In the small white building, J. Frank Duryea designed and built a new generation of six-cylinder engines to power his line of luxury vehicles. Pictured in 1909, the wood-frame building is the only factory structure still standing. In the 1940s, the Chicopee Falls canal was filled in. The river plant burned to the ground in a spectacular 1967 fire.

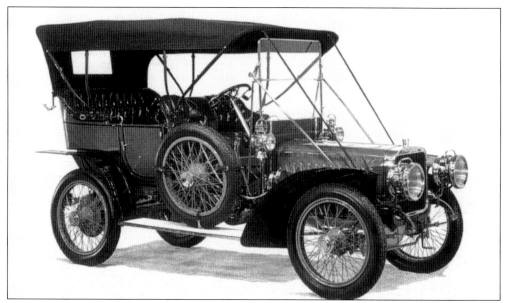

Richard P. Scharchburg, in his book *Carriages Without Horses*, writes that "by 1904, the Stevens-Duryea 'automobile tail' was beginning to wag the 'firearms dog.'" One of the reasons the automobile line was making more money was this classic car, described as a "20th Century Hustler, a five passenger touring car, with a 20 horsepower four cylinder engine and a selling price of $2,500."

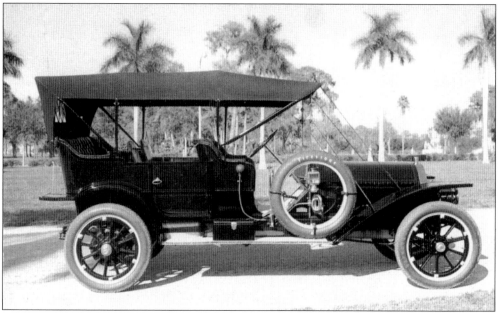

Stevens-Duryea built the quietest cars on the American road. This famous 1909 seven-passenger touring car, with its powerful, nearly silent six-cylinder engine and its aluminum body, sold for more than $4,000. The company produced only six models, and the continuation of the same models season after season was an established policy. It was understood that before any car was offered to the public, it was made right; there was nothing of the usual cut-and-try construction.

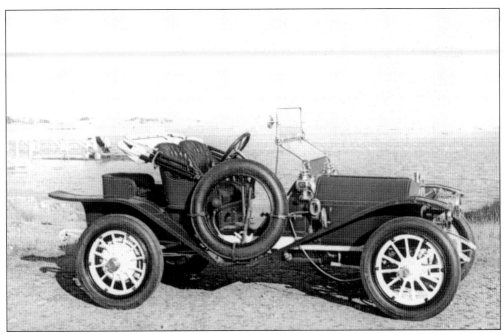

Capable of reaching speeds of 50 miles per hour, this 1910 roadster, with its lightweight chassis and its 4-cylinder, 36-horsepower engine, was considered a "delight to drive." It sold for $2,900. In 1911, the company reached a high-water mark, earning more than $1 million in profit in a single 12-month period. Stock in Stevens-Duryea was selling at between $500 and $600 a share.

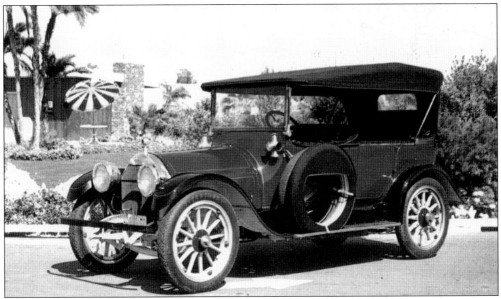

This 1915 Big Six touring car was the last of the line produced in Chicopee Falls. A large military order from the government of Russia led to a suspension of automobile production. Following America's entry into World War I, the company shut down the automotive division. J. Frank Duryea moved to Groton, Connecticut, where he spent the rest of his life designing powerboats for racing.

On September 7, 1942, the citizens of Chicopee honored the community's most famous native son, Gen. Arthur MacArthur. Dedication ceremonies were held at the junction of East Street and Broadway; the flagstone rotary at the top of the hill became known as Gen. Arthur MacArthur Square. In the center of the memorial is a huge sphere of dark polished granite weighing over 4,000 pounds, which symbolizes the globe. It was viewed as a fitting tribute to a 19th-century military hero who fought American wars on the continent and in the Pacific Islands.

On July 26, 1951, Arthur MacArthur's son Douglas visited his father's birthplace, the Belcher Homestead. He found that it had been moved to the rear of a large bridal and flower shop. Nevertheless, the great hero of World War II acknowledged the cheers of the approximately 10,000 people who surrounded the square. Ironically, in the summer of 1975, the monument itself was moved to a new site on Church Street.

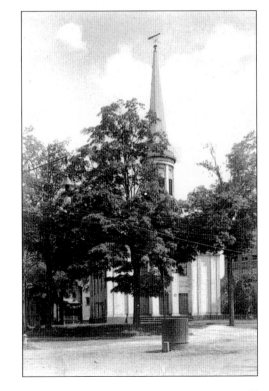

The most popular postcard subject in Chicopee Falls was the Methodist church at the top of the hill. The church building, constructed in 1842, is the oldest religious structure in Chicopee Falls. In this image, the old fire cistern stands in the middle of the intersection.

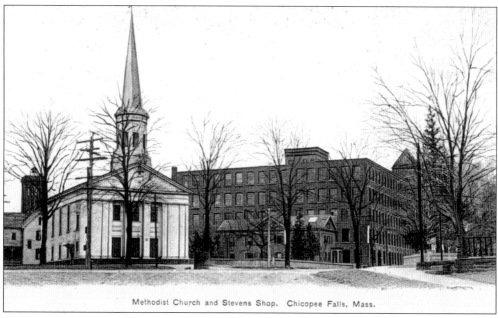

In this postcard, the white church shares billing with the J. Stevens Arms shops. Following the collapse of the bicycle industry, A. H. Overman, the maker of the famous Victor bicycle, sold the property to the shotgun maker.

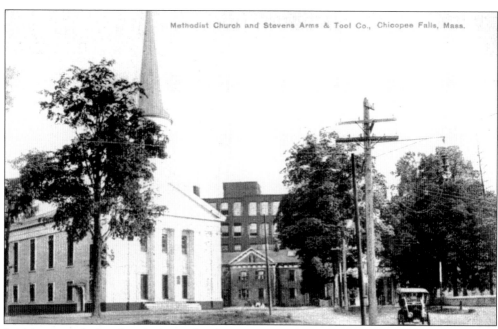

In this postcard, the church shares the scene with telephone poles and what appears to be a Stevens-Duryea automobile. When the original Duryea Wagon Company went out of business in 1898, Charles Duryea returned to Indiana. J. Frank Duryea remained in the area and, in 1901, entered into a partnership with Irving Page, president of the Stevens Arms Company. The company built 15,000 luxury automobiles in Chicopee Falls and East Springfield.

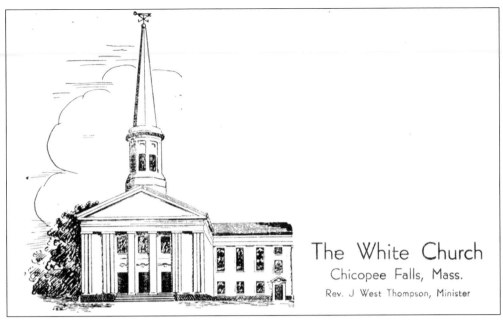

The White Church
Chicopee Falls, Mass.

Rev. J West Thompson, Minister

Rev. J. West Thompson served the church on the hill from 1943 to 1946. The popular minister promoted church organizations, plays, and musicals, and he produced this postcard as one of his many fund-raising efforts. Church history indicates that the popular pastor left the church for a new assignment in a larger city.

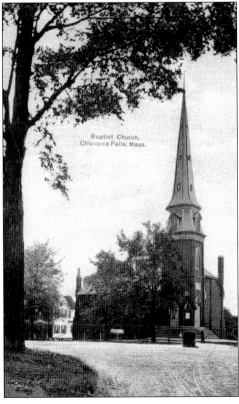

The other church in MacArthur Square was the First Baptist Church. In this early 20th-century postcard, the road is still unpaved. The Baptists built their first church in Chicopee Falls in 1832; this handsome Gothic-style church was constructed in 1877. The longest pastorate was that of Rev. Rufus K. Bellamy, who became pastor of the church in 1848 and served for 34 years. Bellamy died in 1886, the year before his son Edward Bellamy published *Looking Backward*, the world-famous utopian novel.

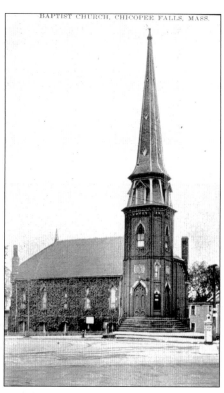

In this more recent postcard, the fire cistern has been replaced by a traffic marker and the road has been paved. At the annual church meeting in 1931, a proposed merger with the Central Baptist Church of Chicopee was approved. In recent years, the congregation has grown, and the classic old church has been tastefully modernized with the addition of a handsome new family center.

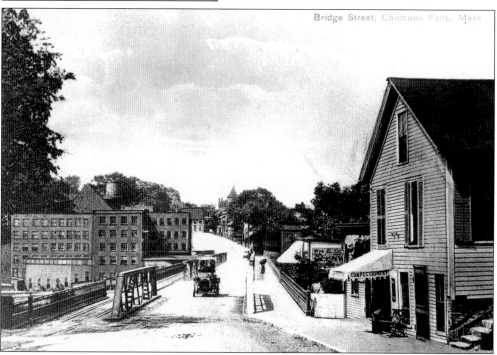

From 1901 to 1915, the Duryea touring car was added to most of the postcards of local outdoor scenes. This *c.* 1909 postcard features the new open-decked iron bridge, which provided separate travel ways for trolleys, automobiles, and foot traffic.

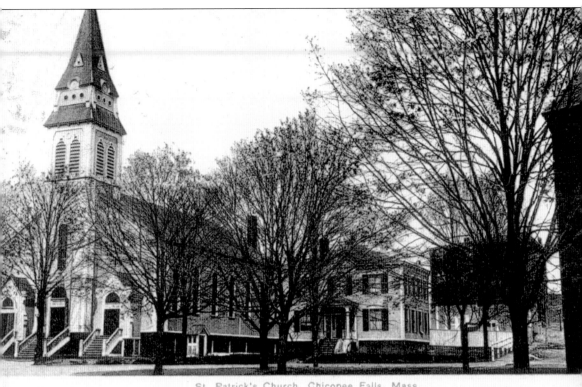

St. Patrick's Church, Chicopee Falls, Mass.

The first known Catholic resident of Chicopee Falls was Tom Brennan, who arrived with his wife in 1825. Brennan came to Chicopee Falls to help build the new canal for the Chicopee Manufacturing Company. The Irish immigrant enclave was established on the north side of the Chicopee River. The homes and rooming houses were constructed on Montgomery, Grattan, and Sheridan Streets. On May 12, 1872, the cornerstone was laid for St. Patrick's Church on Sheridan Street.

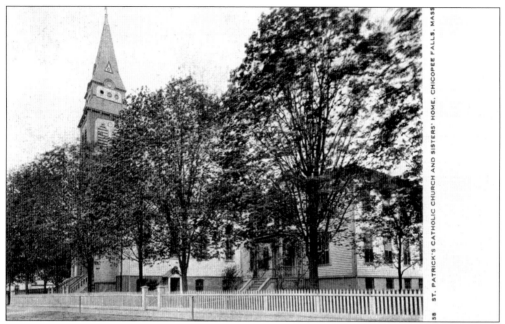

According to Dr. John J. McCoy's *History of the Springfield Diocese*, the first Mass was said by Rev. Patrick Stone on December 15, 1872, the day the old St. Patrick's Church was dedicated. Until that time, the Irish Catholics in Chicopee Falls had attended Mass at the Holy Name Church in Chicopee, two miles away. Father Stone served as pastor until his death in 1905.

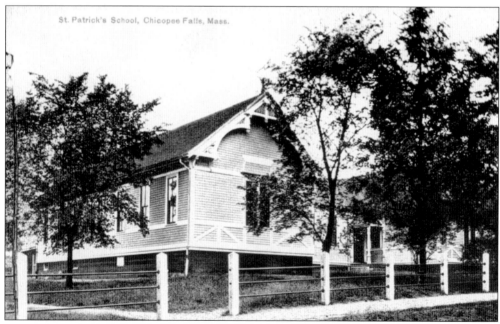

In 1880, the parish purchased land on the corner of Columba and Montgomery Streets and constructed a new parochial school. The Sisters of St. Joseph were invited to take over the conduct of the school. This postcard highlights the unique one-story, wood-frame school building, which served the needs of the parish for 90 years.

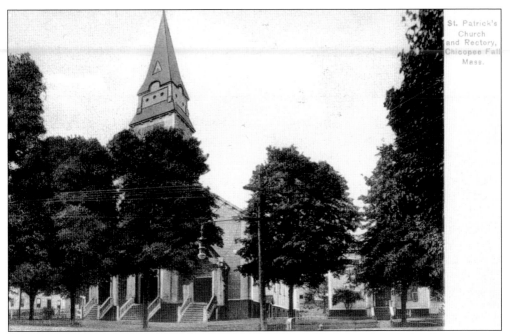

This full-color postcard from the early 20th century was taken following a full-scale renovation. Note the new streetlight. Father Stone renovated the entire church property, repainting both buildings, replacing the roof, and repairing the steeple. The church purchased a new organ and enlarged the choir gallery.

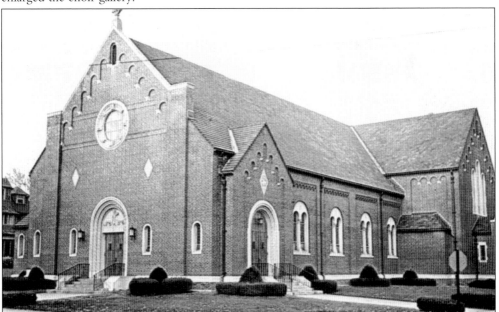

This 1950s postcard shows the new St. Patrick's Church on Broadway in Chicopee Falls. Rev. John R. Rooney became the pastor of St. Patrick's in 1936. During his pastorate, the Page Mansion was acquired for a rectory and the adjoining property on Broadway between Madison and Hendrick Streets was acquired for the site of the new church. The new red brick, Romanesque-style church, with a seating capacity of 800, was dedicated on Sunday, May 8, 1949.

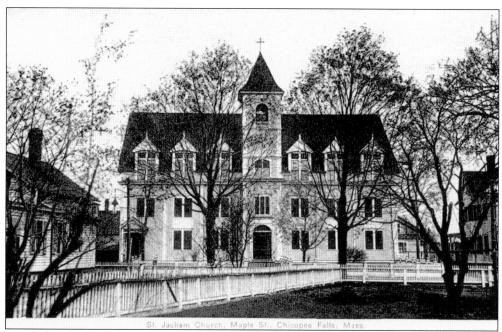

In 1898, a book about the Catholic Church in New England described St. Joachim's parish as a church with a beautiful hall, a fine presbytery, and spacious, well-kept grounds. Rev. Alexis Delphos reported a membership of 1,400 souls. In 1923, the parish name was changed to St. George Church, a new church was constructed on Belcher Street, and a new parochial school was built on the Maple Street site of the old church.

St. Joachim's Parish House on East Main Street was purchased by Father Delphos for $7,500. To this day, the splendid Caldwell family mansion, with its distinctive white pillars, serves as the presbytery for St. George Church.

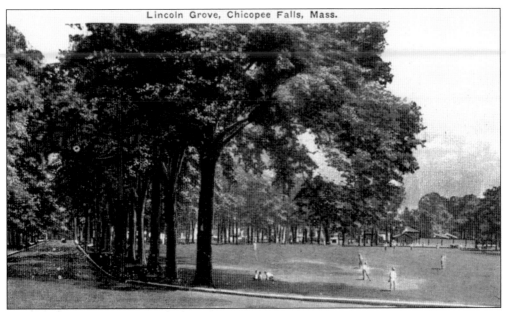

Lincoln Grove, Chicopee Falls, Mass.

The largest open space in Chicopee Falls was at the intersection of Grove Street and Broadway. The property was donated to the city by industrialist Irving Page. In 1910, the city had appointed a playground committee to develop new parks in the city. Lincoln Grove was the first large public playground with a major-league-sized baseball diamond. The famous Fisk Red Tops played their home games at the grove, drawing large crowds for Sunday doubleheaders.

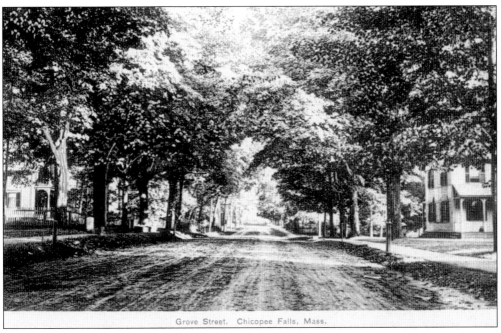

Grove Street. Chicopee Falls, Mass.

Tree-lined Grove Street was one of the new city's most attractive neighborhoods. At the start of the 20th century, several new Queen Anne–style homes were constructed near Lincoln Grove Park.

In 1888, some Chicopee Falls businessmen made a serious departure from their usual investment practices. They incorporated a building and real estate company with the express purpose of aiding a good class of citizens to procure homes by small payments and fair interest. New homes were built on East Street and Broadway.

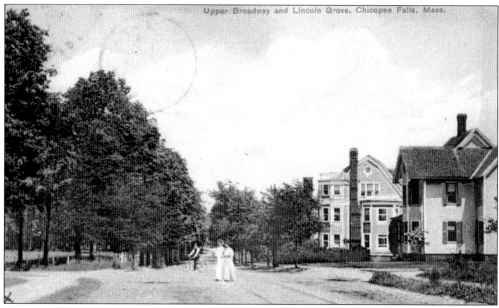

The impressive Lincoln Grove neighborhood pictured here was a direct result of the efforts of the Chicopee Falls Building Company. Construction began in 1890 and continued into the first decade of the 20th century. Bordering Broadway (then called Springfield Street), new streets in the area were named for American presidents (such as Washington, Madison, Monroe, and Lincoln) and the Arlington National Cemetery.

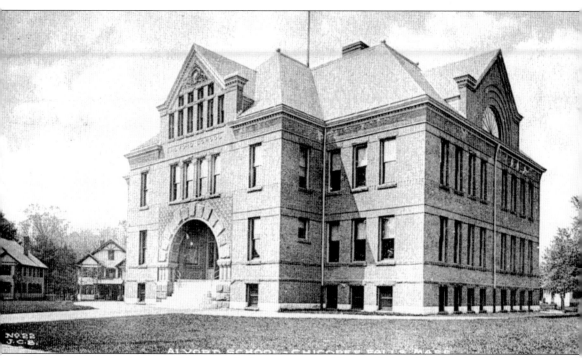

In her book *The Architectural Heritage of Chicopee*, Kristin O'Connell describes the Alvord School as the last 19th-century variation on medieval styles. The Richardson Romanesque style is named for its creator, the great American architect Henry Hobson Richardson. The Alvord School on Broadway in Chicopee Falls was built in 1893. The structure features the Richardson arch, a broad Syrian arch springing directly from the ground and creating a cavelike effect around the main entrance. Today, the building houses the central administration offices of the Chicopee public schools.

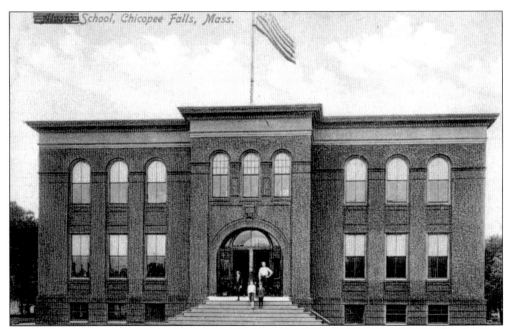

School, Chicopee Falls, Mass.

This postcard incorrectly identifies the school as the East Street School. The school, which is over 100 years old, is actually on Southwick Street and was never called the East Street School. In fact, from the outset it was called Belcher School. Following its construction, the school was named for Bildad Barney Belcher, who started teaching in Chicopee in 1829. In the 19th century, the Belcher family was prominent in the Chicopee Falls community.

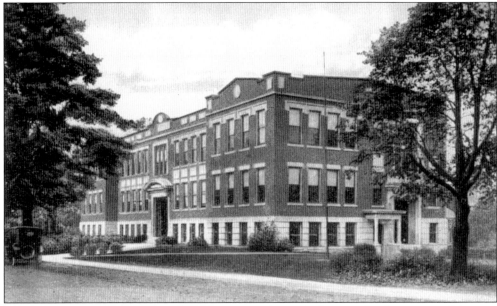

On January 5, 1891, Chicopee industrialist George S. Taylor became the first mayor of the new city of Chicopee. In 1910, a new school was built on Belcher Street in Chicopee Falls. The school committee named the building in Taylor's honor. Taylor remains the only chief executive so recognized. The school was demolished in 1970 as part of the Chicopee Falls urban renewal program.

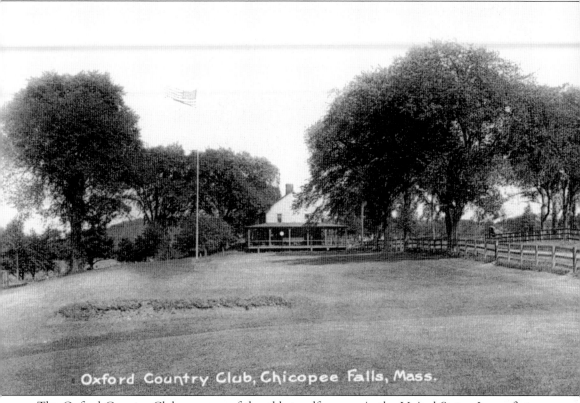

Oxford Country Club, Chicopee Falls, Mass.

The Oxford Country Club was one of the oldest golf courses in the United States. It was first organized in 1889 by a small group of Chicopee sportsmen who were intrigued with the game of golf. The 1889 layout was on the south side of East Main Street, where nine holes were crowded into a small area of rugged land that had been cleared of dense brush and trees.

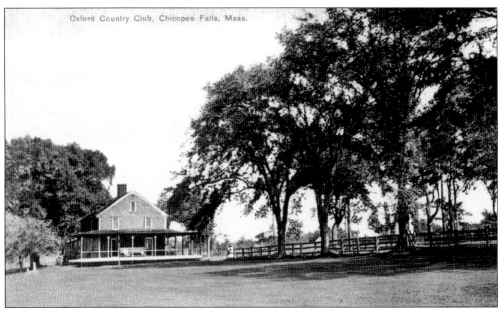

In 1895, the country club purchased the Warner farm on the north side of East Main Street. The farmhouse was converted into a clubhouse, and the course was enlarged and realigned along the Chicopee River.

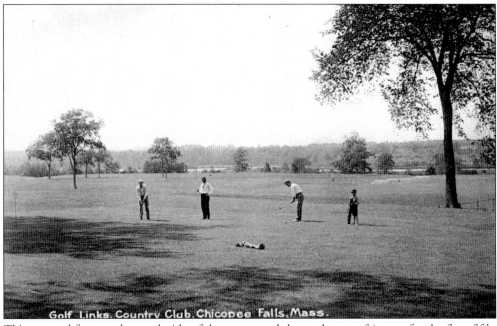

This postcard features the north side of the course and shows the new fairways for the first, fifth, sixth, seventh, eighth, and ninth holes near the Chicopee River.

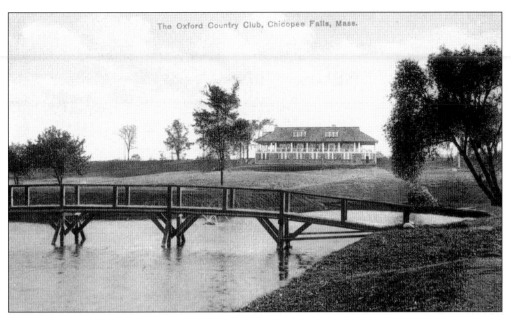

Prior to 1910, the Oxford Country Club had an up-and-down history. Then came a reorganization that produced $15,000 in capital stock for the corporation. With this money, the clubhouse was renovated and the course upgraded. This postcard features a view of the club's signature fifth hole.

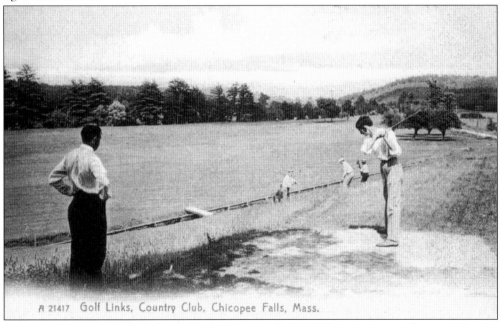

A 21417 Golf Links, Country Club, Chicopee Falls, Mass.

The challenging nature of the Oxford Country Club's golf course was duly noted by the newspapers. The *Springfield Republican* of June 27, 1915, stated, "The asset of which the club is proudest is the golf course. Anyone inclined to sniff at a nine hole course these days when 18 holes are standard should remember that no amateur or professional has ever beaten par (74) on the Oxford Course." The golfers on the postcard were teeing off on the first hole of a difficult nine-hole golf course.

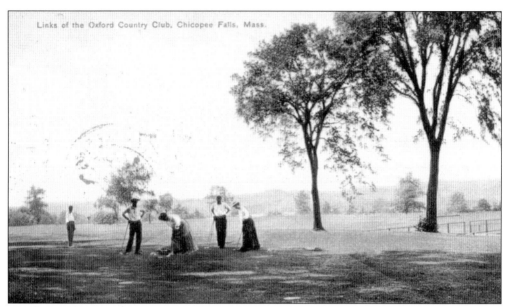

In addition to the golf links, the club had two excellent tennis courts, and a scenic view of the Chicopee River and Mount Tom from the spacious piazzas made it one of the most attractive layouts in the region. The *Springfield Republican* concluded that such assets brought increasing prosperity to the club; membership in 1915 was over 325.

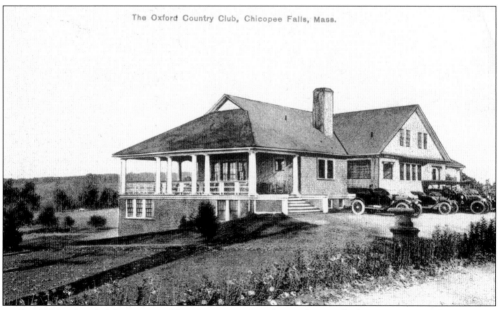

In the 1920s, the club began an off-again, on-again relationship with the sporting goods company A. G. Spalding and Brothers. Spalding, a major producer of recreational golf equipment, had manufacturing facilities in Chicopee Falls and Chicopee Center. As the game grew in popularity during the Roaring Twenties, Spalding brought the club's first resident professional over from Scotland. His name was Jack Clark, and his job was to encourage golf as a recreational activity for men and women.

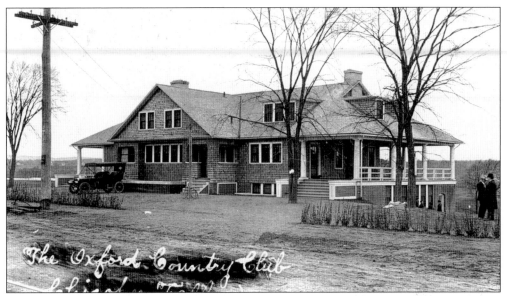

This postcard offers a view of the Oxford Clubhouse in winter. During the boom years of the 1920s, the Spalding Company became a world leader in the sale of golf equipment. The company leased the club's facilities on a year-round basis and used the par-five third fairway to test new golf balls. Golf outings drew business customers from all over the country, and clambakes at the Oxford club were legendary events. Professional golfers who endorsed Spalding equipment provided demonstrations and clinics at these company events.

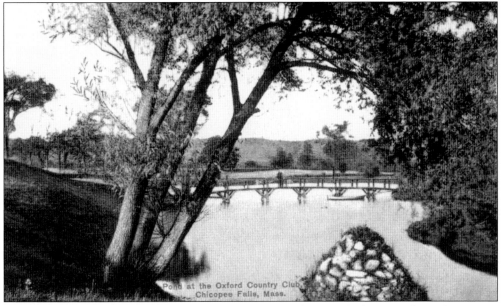

The fifth hole, with its picturesque pond, was the most photographed site on the course. It was there on a windy August afternoon that a gallery of more than 1,000 fans watched, spellbound, as Walter Hagan's drive came within inches of a hole in one. That day, Hagan fired a course-record 65 to win the Spalding-sponsored tournament. Hagan, the greatest professional golfer of 1929, played his signature Spalding clubs and wowed the crowd with the accuracy and distance of the company's new Kro-Flite golf balls.

A 21413 The Bend in the River, Chicopee Falls, Mass.

Glad you are enjoying life. Most time to go to Pittsburg, isn't it? Elsa.

The Chicopee River was most probably named by local Native Americans before the arrival of the Puritans. The word itself is from the Algonquin dialect. *Chickee* or *chikeyen* means "it rages," or "is violent," and *pe* is the root word of water in Algonquin; hence, the meaning "raging" or "rushing water."

The Bend in the Chicopee River, Chicopee, Mass.

The Chicopee River is the largest river to flow into the Connecticut River in Massachusetts. It is made up of the Swift, Ware, and Quaboag Rivers, which merge near the Three Rivers section of Palmer. The Chicopee River drains a basin of over 700 square miles.

64

Three
CABOTVILLE

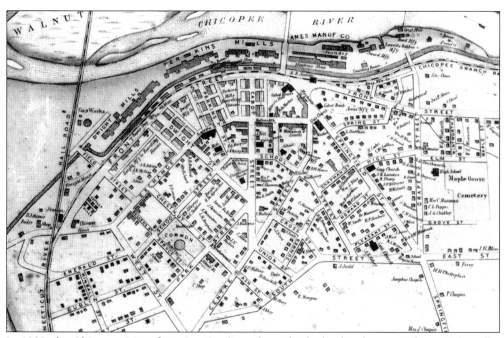

In 1825, the Chicopee Manufacturing Company brought the land and water rights at Cabotville. Three separate companies operated the mills: the Cabot Manufacturing Company, the Perkins Manufacturing Company, and the Dwight Manufacturing Company. In 1856, the year this map was printed, the companies merged and became the Dwight Mills.

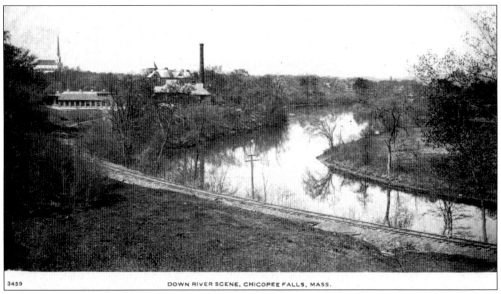

3459 DOWN RIVER SCENE, CHICOPEE FALLS, MASS.

The old Boston & Maine Railroad line hugs this famous curve on the Chicopee River. On this early-20th-century postcard, the spires of the Assumption Church and the Chicopee High School are still in view. The church burned to the ground in 1911, and the high school succumbed to a disastrous fire five years later. The only structure seen here that is still intact today is the original building of the Chicopee Electric Light Company.

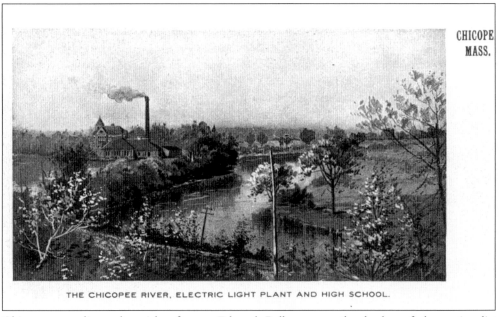

CHICOPE
MASS.

THE CHICOPEE RIVER, ELECTRIC LIGHT PLANT AND HIGH SCHOOL.

Chicopee novelist and social reformer Edward Bellamy was the leader of the nationalist movement in the United States. The nationalists secured the enactment of a law in Massachusetts giving cities and villages the right to operate their own electric and gas utility systems. In this full-color postcard, smoke belches from the stacks of the state's first municipally owned power plant.

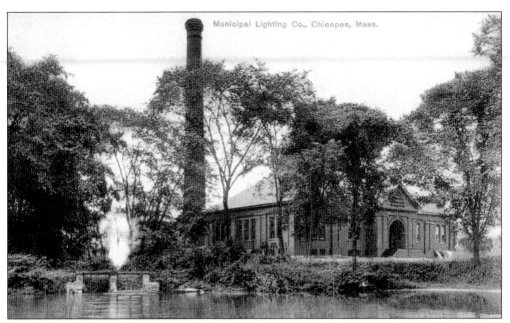

The original building that housed the Chicopee Electric Light Department was built on the site of the old Bemis Brickyard on Front Street. On May 28, 1896, the plant went on line for the first time, with appropriate ceremony. In this vintage postcard, the lower Bemis Pond spillway flows into the Chicopee River.

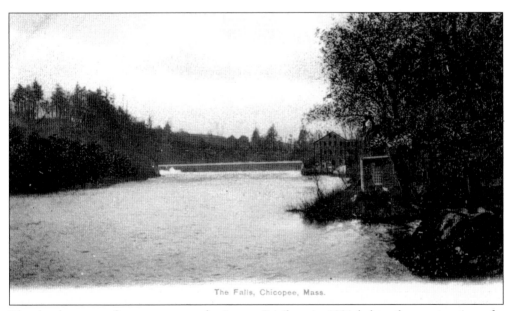

The development of waterpower at the Lower Privilege in 1831 led to the construction of a second dam on the Chicopee River, at Cabotville. The Springfield Canal Company imported Irish laborers to construct the dam, the power canal, and the first cotton mills in Chicopee Center.

A Glimpse of the Chicopee River, Chicopee, Mass.

The dam and canal gates are located at the foot of Ames Avenue. This lovely postcard of Sandy Hill and the lake behind the Lower Privilege dam are today the scenic backdrop behind the new Emily Partyka Main Branch of the Chicopee Library on Front Street.

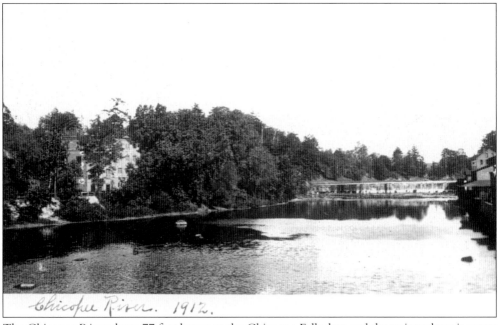

Chicopee River. 1912.

The Chicopee River drops 77 feet between the Chicopee Falls dam and the point where it enters the Connecticut River. Its width expands from 145 feet to 1,200 feet at the mouth, and it is 20 to 25 feet deep at the flood. The building on the left in this 1912 postcard is the old Crystal Springs Brewery.

The shallow rapids at the bend in the river below the Chicopee Center covered bridge is often called the Old Indian Wading Place. Following the lead of the American Indians, the first Puritan settlers forded the river here, making their long journey to the only church in the vicinity, the old First Congregational Church in Springfield.

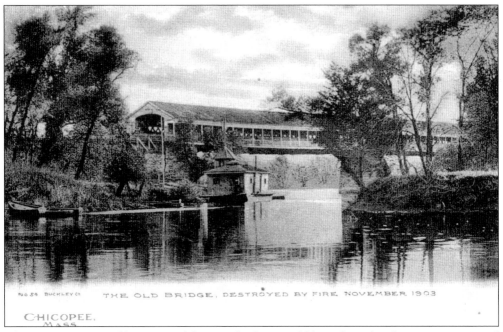

This vintage J. C. Buckley postcard features the famous old houseboat that for years was moored at the mouth of the Chicopee River. The caption on the postcard indicates that the covered bridge no longer exists.

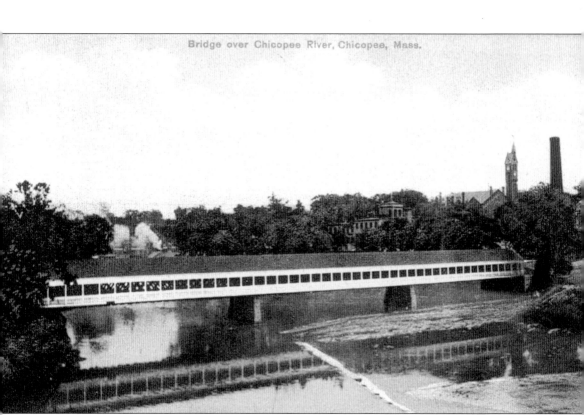

Bridge over Chicopee River, Chicopee, Mass.

In 1783, Springfield selectmen conducted a lottery to raise funds to construct a covered bridge over the Chicopee River. Four years later, according to local legend, Capt. Eli Parsons and the Pittsfield regulators hid on the bridge prior to their attack on the Springfield arsenal during Shays' Rebellion.

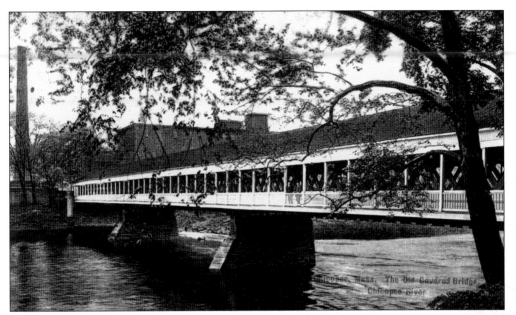

In 1821, using the original foundations, the bridge was rebuilt as an open bridge. Some 25 years later, nationally famous bridge builder Isaac Damon, using a new lattice pattern developed by Ithiel Towne, replaced the open bridge with a state-of-the-art covered bridge.

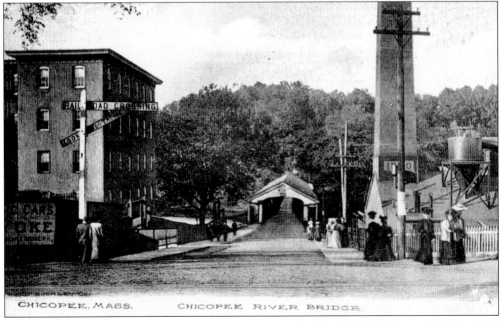

The Damon Bridge, requiring only modest repairs, served Cabotville for 85 years. In this *c.* 1910 postcard view of the Boston & Maine Railroad crossing, the Dwight Manufacturing Company is seen on the left prior to the extensive 1912 expansion. On the right are the A. G. Spalding foundry and wood shops.

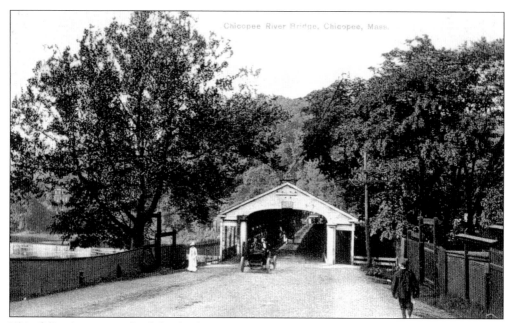

This full-color postcard of the bridge entrance once again features a Stevens-Duryea town car. The photograph was taken about the time that the Dwight Company began construction of two-story tenements and duplexes at Sandy Hill on the north side of the bridge.

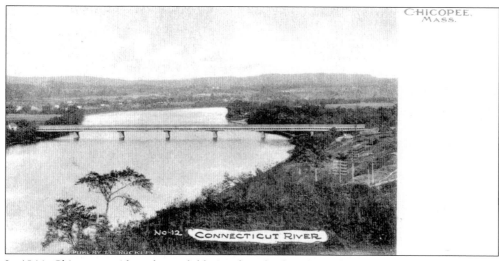

In 1846, Chicopee residents began lobbying for a bridge across the Connecticut River to West Springfield. In 1848, Chicopee declared its independence from Springfield. That year a private company, the Cabot & West Springfield Bridge Company, began construction of a toll bridge.

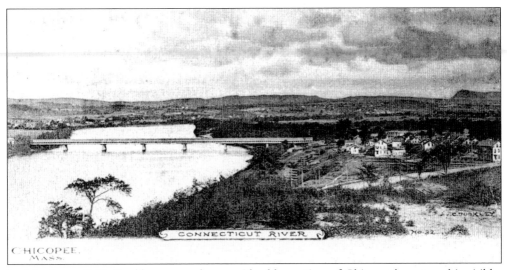

In this vintage J. C. Buckley postcard, a considerable portion of Chicopee's west end is visible. The new bridge, engineered by Isaac Damon, was 26 feet wide and 1,237 feet long.

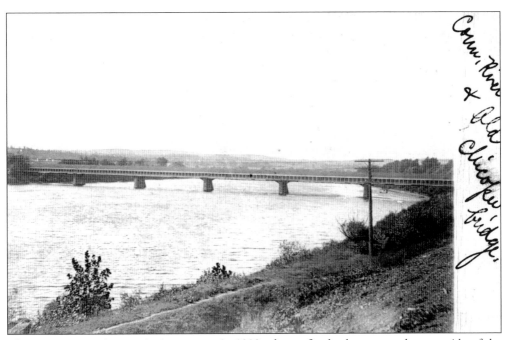

There were extensive repairs in progress in 1903 when a fire broke out on the west side of the bridge. A strong wind spread the fire, and the old bridge was destroyed within minutes.

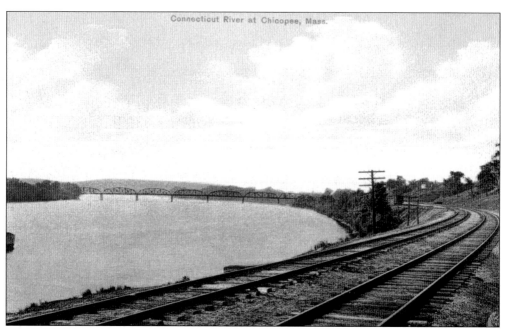

This postcard of the Connecticut River at Chicopee highlights the roadbed of the first railroad line into Chicopee. In 1842, Chicopee businessman Chester Chapin ran the Connecticut Valley Railroad from Chicopee Junction north through Willimansett and across the river to Holyoke.

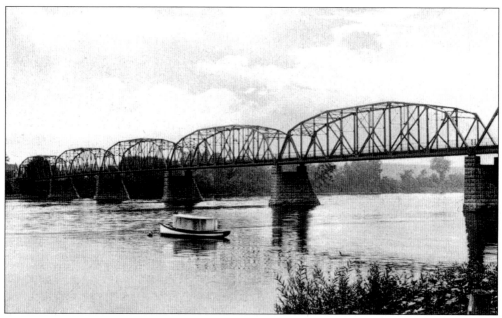

In 1905, a new steel bridge was completed. The bridge was 23 feet wide, and the center was 28 feet above water level. In many ways, the bridge was state-of-the-art for the period. Unfortunately, the narrow, wood-paved structure was built to handle horse-drawn wagons.

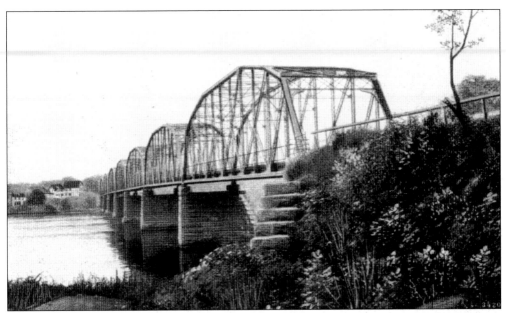

In the 1950s, teenaged drivers played a serious game of chicken with the era's larger vehicles as they sped across the neglected span. In 1969, the opening of Interstate 91 created a new highway bridge to West Springfield, effectively sealing the fate of the old bridge. The span was demolished in 1987.

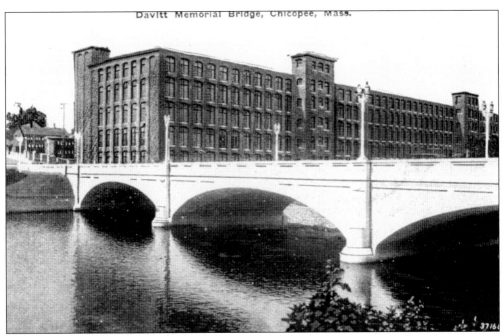

Davitt Memorial Bridge, Chicopee, Mass.

In 1931, the city replaced the old covered bridge in Chicopee Center with a new reinforced concrete bridge. The Fred T. Ley Construction Company completed the bridge in a matter of two months at the height of the Great Depression. It was the company's last major job for several years. The Dwight Mill complex on the river was vacant when the bridge was dedicated.

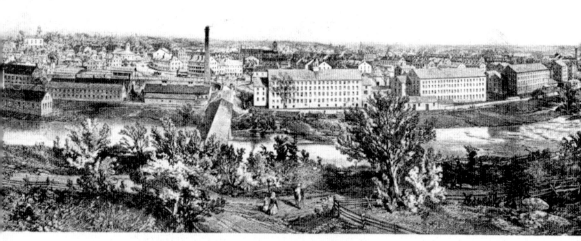

CHICOPEE, MASS. 1856.

NO. 38 PUB. BY J. C. BUCKLEY.

Cabotville is pictured here four years before the outbreak of the American Civil War. The company on the left is the Ames Sword Company. The Dwight Manufacturing Company is on the right. Employment at both companies tripled during the war.

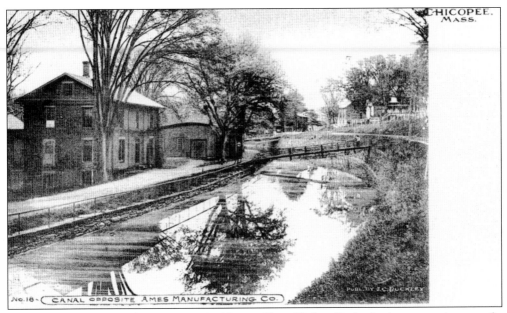

According to Chicopee historian Bessie Warner Kerr, Nathan Peabody Ames was the son of a pioneer family that made tools and cutlery in Chelmsford. Encouraged by industrialist Edmund Dwight, young Ames brought his cutlery business to Chicopee Falls. In 1834, the Ames Sword Company moved to this site on the newly constructed Cabotville Canal.

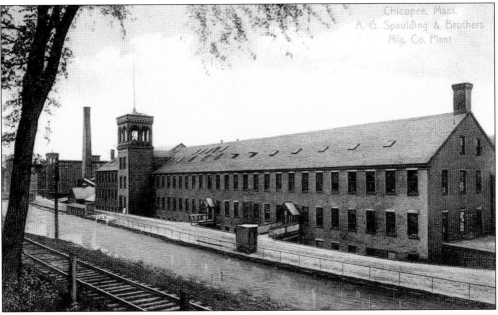

For many years, this building served as the main manufacturing floor of the Ames Sword Company. During the Civil War, the factory was called Lincoln's Arsenal. The facility was a major supplier of cannons and swords for the Union army. In 1904, A. G. Spalding & Brothers, the famous sporting goods manufacturer, moved into the Ames Sword Company factory in Cabotville.

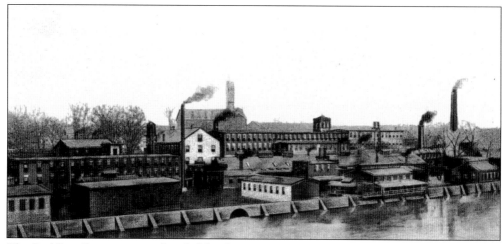

The Spalding Company was founded by former major league baseball pitcher A. G. Spalding. He had developed his own baseball design, which was accepted as the official major league ball in 1876. Spalding retired from the game and, with his brother, organized a company to mass-produce his design. The Spalding ball, with minor changes from the original design, is still used by the big leagues.

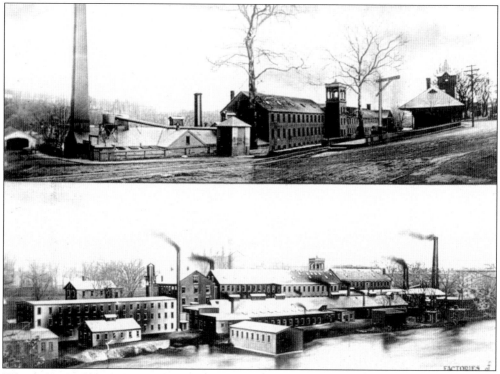

When the Spalding Company came to Chicopee, it was already a world leader in the manufacture of recreational sporting goods. This unusual postcard offers a front view and a river view of the complex *c.* 1910. The upper photograph is framed by the old covered bridge and the Boston & Maine Railroad Station in Market Square. In the lower photograph, adjacent to the Chicopee River, the foundry shops of the Ames Sword Company have been retooled to produce America's first golf clubs.

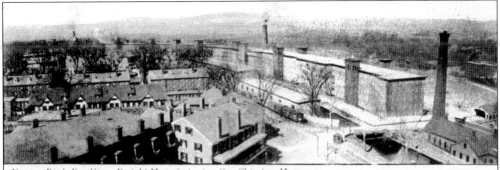

No. 1. Birds Eye View, Dwight Manufacturing Co., Chicopee, Mass.
F. M. Gilbert, Publisher.

Today, these factory buildings house the Cabotville Industrial Park. The tenement housing has been replaced by a shopping plaza and retail shops. Three separate companies first operated the mills; the Cabot Company, the Perkins Company, and the Dwight Mills shared the space. In 1856, the three merged under the Dwight name.

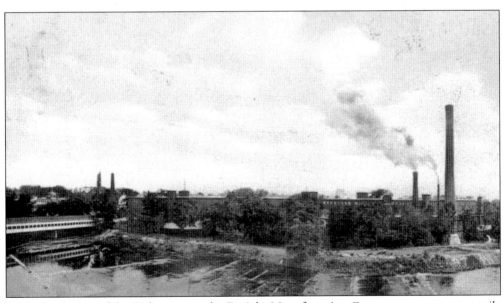

At the beginning of the 20th century, the Dwight Manufacturing Company was a quarter-mile of mill buildings that covered 1.3 million square feet of space and spread over 14 acres at the edge of the Chicopee River.

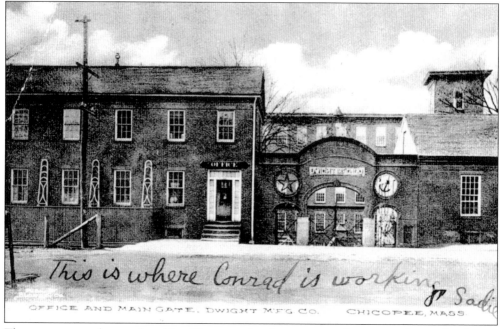

This is where Conrad is working

J'° Sadie

OFFICE AND MAIN GATE, DWIGHT MFG CO. CHICOPEE, MASS

The company used more than 15 million pounds of cotton annually to manufacture the famous Anchor brand of cotton cloth. The company served a global market. The Dwight Anchor brand of sheeting was the Cadillac of cotton sheets, while the affordable Star brand was the nation's best-selling bedsheet. Here at the main gate, the company's trademarks remain to the present day.

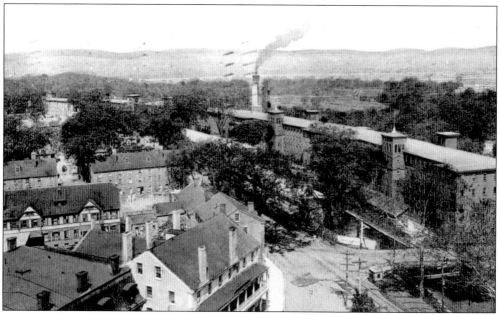

This closeup view shows the company's boardinghouses. Located near the mill, they were fitted with all the comforts of home. Neatly kept, they were well lighted, ventilated, and heated. Meals were prepared of the best-quality foods by capable cooks in modern, sanitary kitchens. Families lived in tenements on Perkins, Cabot, Dwight, and Exchange Streets.

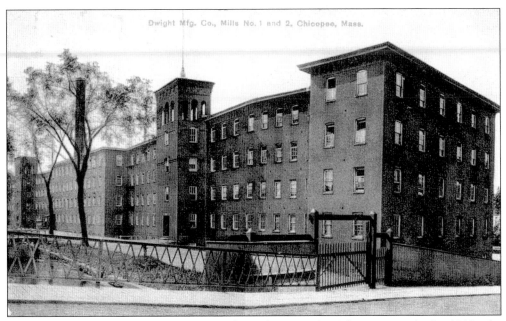

The Dwight Mills employed 2,000 people and operated 54 hours a week. In 1915, the schedule was arranged so that the factory closed at 5:30 p.m. each day except Saturday, when it closed at noon.

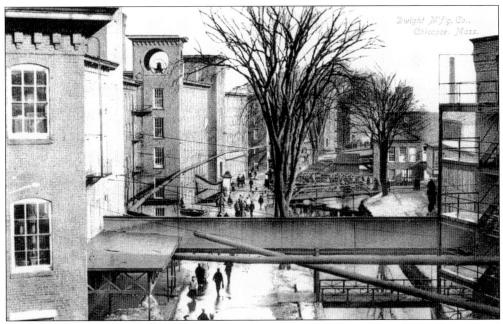

In 1924, the banking house of J. P. Morgan & Company of New York established operational control of the Dwight Mills. Three years later, Morgan interests, with very little warning, shut down the entire mill operation. The company moved to Alabama, idling 2,000 Chicopee workers and bringing the Great Depression to the region.

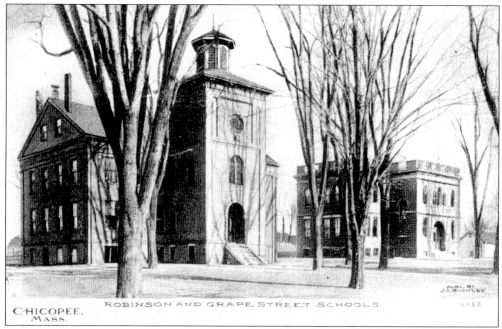

The building on the left was the first high school in Chicopee Center. The school, originally called the Grape Street School, was renamed in honor of Gov. George Dexter Robinson, the principal of Chicopee High School from 1865 to 1866.

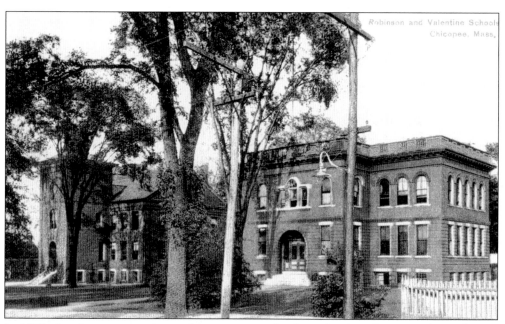

In 1899, the city constructed a modern grammar school on the site adjacent to the Robinson School. The school was named for longtime Chicopee educator William Valentine. The Robinson School was demolished in the 1950s, and the renovated Valentine School was converted to apartments.

Chicopee became a city in 1890. For over 50 years, the city maintained two separate high schools. A new central high school, symbolically located on Front Street halfway between Chicopee Falls and Chicopee Center, opened in 1891.

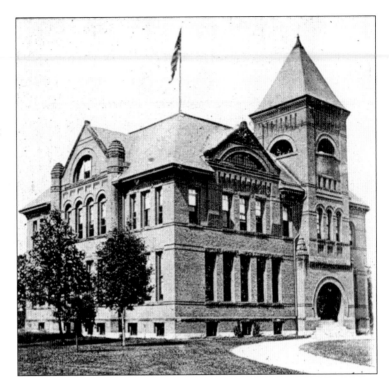

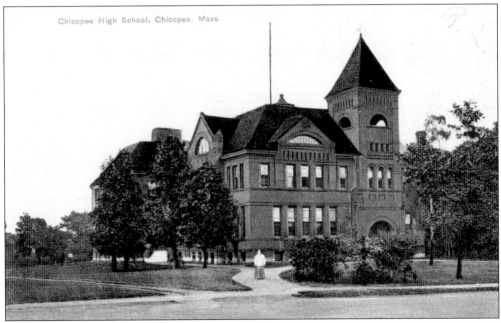

Chicopee High School, Chicopee, Mass.

When the new Central High School opened, former Gov. George Dexter Robinson attended the dedication ceremonies as the honored guest. At the ceremonies, the school board announced that the old high school would be renamed in his honor. A manual training program was introduced at the high school in 1908.

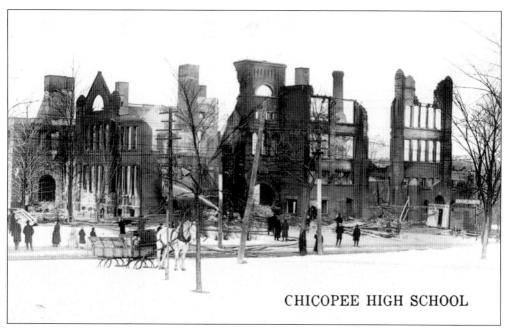

CHICOPEE HIGH SCHOOL

Because of increased enrollment, in 1915 the board of aldermen approved the construction of a substantial addition to the high school. On the bitterly cold night of January 17, 1916, a fire broke out in the annex, which was still under construction. The following morning, the citizens of Chicopee awoke to find their high school a complete ruin.

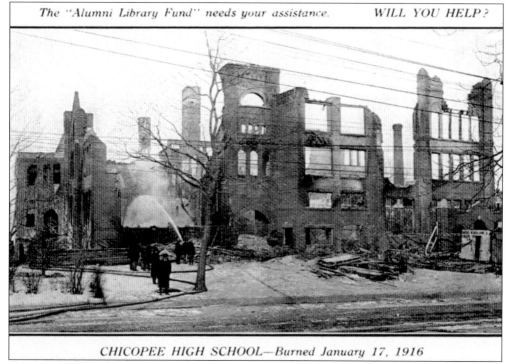

The "Alumni Library Fund" needs your assistance. WILL YOU HELP?

CHICOPEE HIGH SCHOOL—Burned January 17, 1916

During construction of the new high school, the Chicopee High School Alumni Association used this postcard as a fund-raiser for the new library.

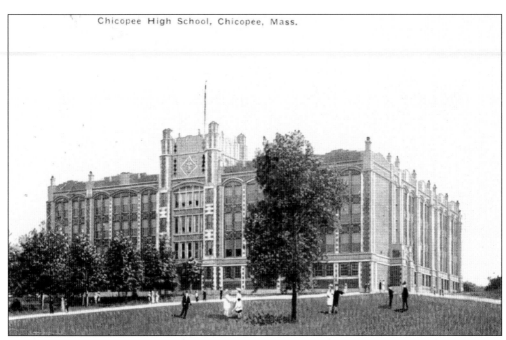

Across the street from the fire site, the city constructed a new $1 million facility. The new structure was not without controversy. Mayor Daniel J. Coakley presided over the dedication ceremonies when the school opened in the fall of 1920. Critics of the project referred to the school as "Coakley's Folly," pointing out the 20 unused classrooms and wondering aloud why the building cost so much.

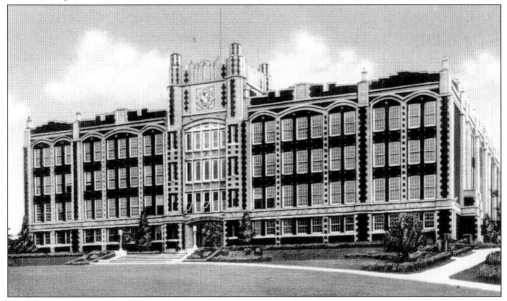

In the 1940s, when this postcard was printed, Coakley's Folly was no longer adequate; 1,400 students were attending classes in the school. Some students had to study in six portable classrooms at the rear of the school. In 1979, the city spent $3 million to renovate and restore the building. In June 2004, Chicopee High School students were moved to a new facility built on the former site of the city infirmary.

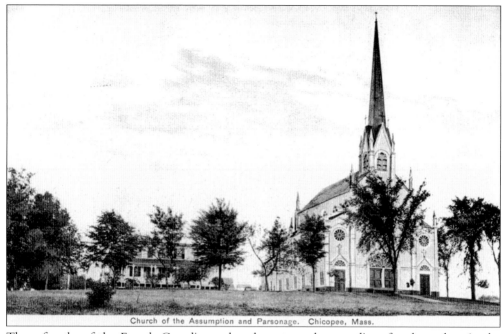

Church of the Assumption and Parsonage. Chicopee, Mass.

Three-fourths of the French Canadians who chose to make new lives for themselves in the Pioneer Valley's "Little Canadas" came to Chicopee during the years 1870 to 1890. The first Assumption Church was built on Academy Street in 1874. Pictured here is the second church, which was constructed on Front Street in 1885. A fire destroyed the building in 1911.

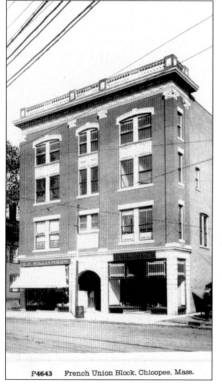

P4643 French Union Block. Chicopee, Mass.

L'Union Canadienne was organized in 1886 by Dr. F. X. Deroin. The society formed to promote French culture, and over the years it evolved into a powerful force in local politics. Its impressive headquarters on Center Street was constructed in 1910. Following the Assumption Church fire, the hall was used as a church until a new church was dedicated.

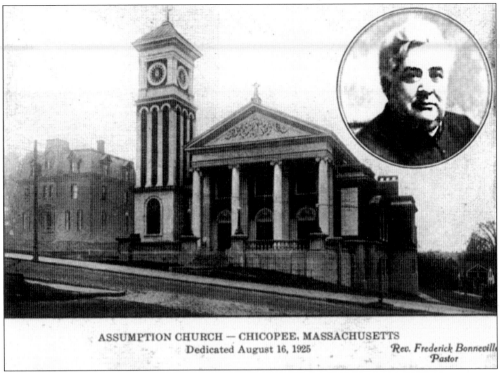

ASSUMPTION CHURCH — CHICOPEE, MASSACHUSETTS
Dedicated August 16, 1925 *Rev. Frederick Bonneville*
Pastor

In this postcard, Fr. Frederick Bonneville is shown with the brand-new Assumption Church on Springfield Street. The parish raised over $200,000 to erect a fireproof edifice in Chicopee Center.

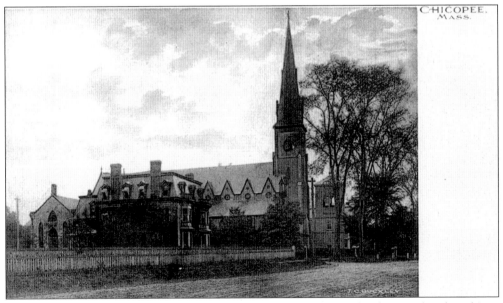

The Church of the Holy Name of Jesus, built from 1857 to 1859 by famous church architect Patrick C. Keeley, is the first church in the city to be built in the early Gothic Revival style.

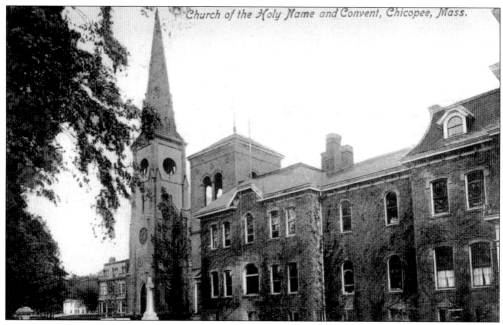

This postcard shows the Holy Name School complex, which was constructed in a variety of Italianate and Second Empire forms that were united by common brick building materials. The large Italianate tower of the girls' school is balanced by an identically proportioned, mansard-roofed version of the school that served as a convent.

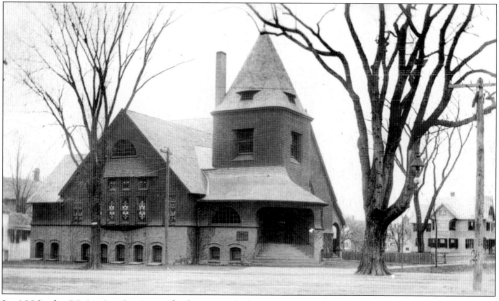

In 1893, the Unitarian Society of Chicopee dedicated its new church at the corner of Fairview Avenue and Grape Street. This postcard features a view of the church from the South Street side of the intersection. Back in those days, many of Chicopee's most prominent citizens were members of this church.

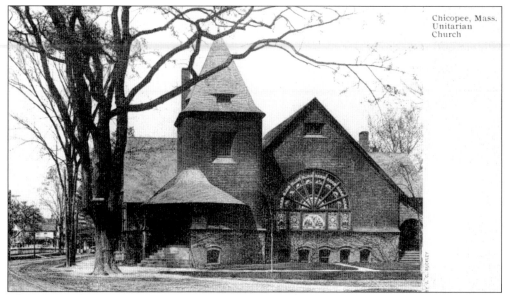

This image of the Springfield Street side of the Unitarian church provides a view of the famous Tiffany stained-glass windows, designed and installed by the New York company at a cost of nearly $25,000. The windows were reportedly paid for by a single donation from former governor George Dexter Robinson. As a footnote to the story, it just so happens that $25,000 was the exact amount of Robinson's fee for his successful defense of Lizzie Borden in the sensational Fall River murder trial in 1893.

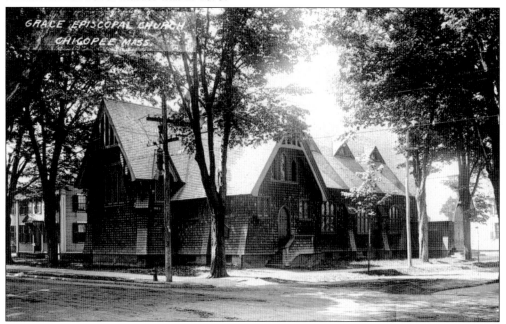

In 1891, Rev. Newton Black became the rector of the Grace Episcopal Church on Cabot Street. Historian Bessie Warner Kerr writes that when he took over, "the whole city woke up." Seven years later, Black personally supervised the building of the new church on the corner of Springfield and Pleasant Streets. He also organized the city's first youth sports program; his boating and basketball teams became famous throughout the state.

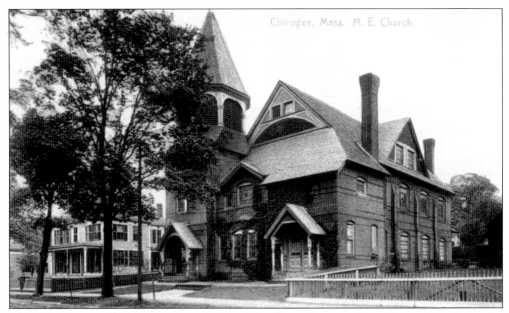

The old Chicopee Methodist Episcopal Church is still standing on Center Street. The distinctive Victorian Gothic church was constructed in 1884. In 1925, when the congregation merged with the Third Congregational Church to form the Federated Church, the building was sold to the Independent Order of Odd Fellows.

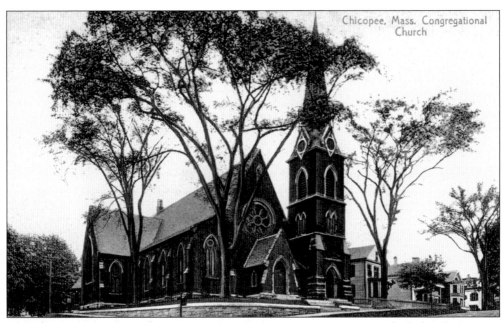

According to legend, 12 men of the Cabotville section met in 1834 to find out "how many Congregationalist professors lived here and how many others could be looked upon as hopefully pious." The results of that first meeting are still seen today. Designed in 1871 by Charles E. Parker, the Boston architect who designed the Chicopee City Hall, the church at the corner of Pearl and Springfield Streets remains as a classic example of Victorian Gothic architecture.

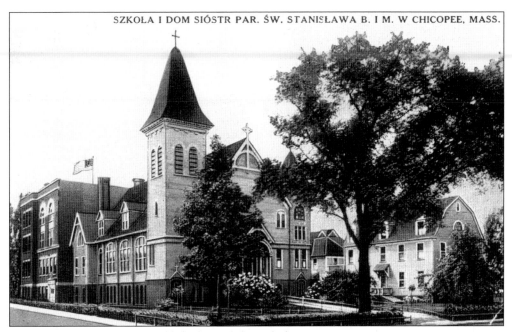

SZKOŁA I DOM SIÓSTR PAR. ŚW. STANISŁAWA B. I M. W CHICOPEE, MASS.

Rev. Stanislaw Chalupka established a Polish Catholic congregation on Front Street in 1890. Within five years, a church was constructed, followed quickly by a convent and a brick parochial school that was attached to the church.

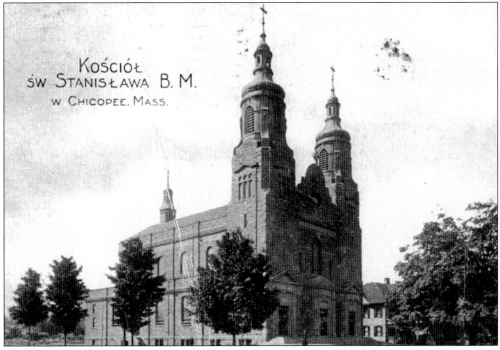

Kościół ŚW STANISŁAWA B. M. w Chicopee. Mass.

This 1908 postcard shows the new St. Stanislaus Church, a brownstone adaptation of a Baroque church design. The structure is Chicopee's most distinguished 20th Century Revival building.

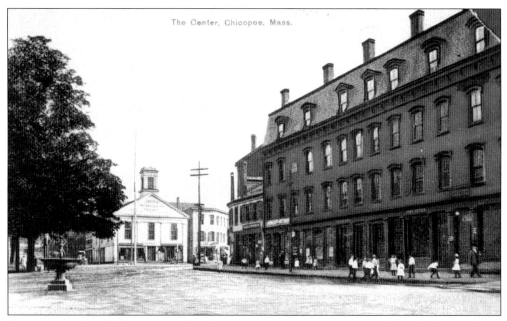

Prominent in this 1905 postcard of Market Square is a white church building. Built in 1836 by the Chicopee Universalist Society and purchased in 1897 by a Presbyterian congregation, the church also served as a prime commercial location. Historian Michele Plourde-Barker wrote that the church "was a unique mixture of sacred and secular spaces." In 1905, the church was renting space on the first floor to a grocery store.

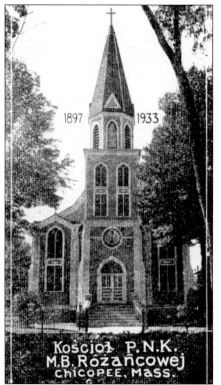

The Polish National Church is located on Bell Street and is called the Holy Mother of the Rosary Church. When the church was built in 1897, there were 600 communicants. In 1933, a disastrous fire nearly destroyed the church. The members of the parish rebuilt their classic turn-of-the-century wooden structure, which remains a unique and impressive local landmark.

92

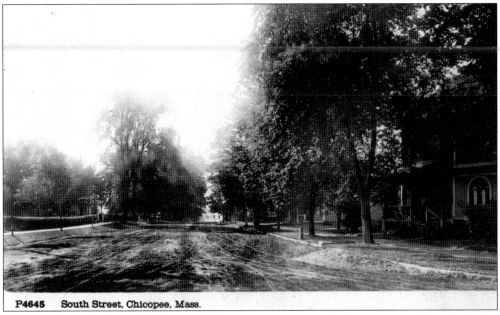

P4645 South Street, Chicopee, Mass.

In 1889, the city's Springfield Street neighborhood was recognized as a national historic district. This national recognition was brought about largely through the efforts of city planner Michele Plourde-Barker. She wrote that "Springfield Street reflects nearly two centuries of residential development which paralleled Chicopee's industrial development. It is exceptional in that it contains a broad range of housing types and styles which paint an eloquent picture of the social and economic levels dividing an industrial community."

In the 17th century, Springfield Street was a major highway between Springfield and the north. The first bridge across the Chicopee River was constructed in 1778. It was at this time that the first known settlement was made in the district. In the 19th century, the district changed from a sparsely settled farm area to a heavily settled residential neighborhood. Depicted in this vintage postcard is the district's signature intersection of Grape, South, Fairview, and Springfield Streets.

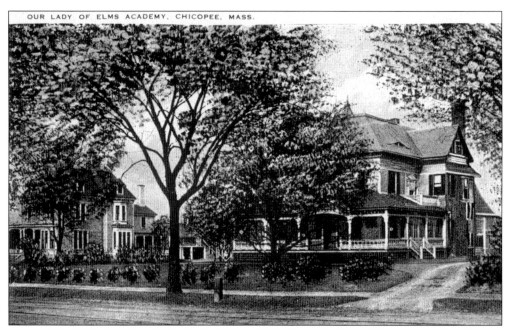

The Spalding House on Springfield Street is a splendid Queen Anne–style home. The elaborate silhouette, abundance of porches and gables, and profusion of ornament are all characteristic of the style. The magnificent home has 48 windows and 7 fireplaces. Today, the mansion is on the National Register of Historic Places and serves as the admissions office of the Elms College.

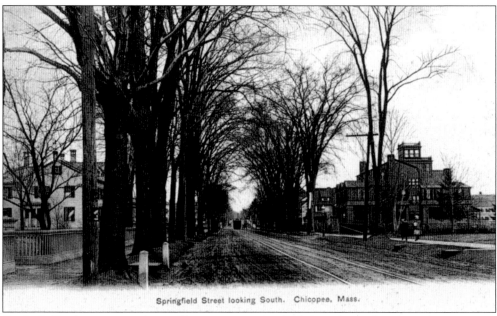

Springfield Street looking South. Chicopee, Mass.

Frank E. Tuttle, a partner in a mill waste concern called the Olmstead and Tuttle Company, entered into the real estate business with James L. Humphrey. The pair purchased the 50-acre Veranus Chapin Farm on the west side of Springfield Street. Depicted in this postcard is the large gambrel-roofed house that Tuttle built himself in 1888. Today, the beautiful home, with its wraparound porches, porte-cochere, and rooftop observatory, is the Grise Funeral Home.

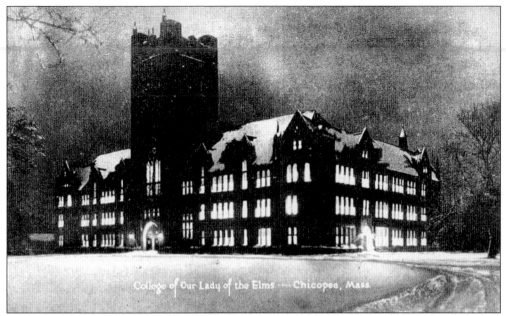

This postcard depicts the Elms College on a winter night. The college, founded by the Sisters of St. Joseph, is a Catholic liberal arts coeducational college. In 1880, at the invitation of Bishop Patrick T. O'Reilly, the Sisters of St. Joseph came to Chicopee Falls; in 1897, in order to accommodate boarders as well as day students, they opened an academy in Pittsfield. In spite of an an auspicious beginning, the Pittsfield academy did not prove feasible and, two years later, it moved to Chicopee.

On January 13, 1899, the Springfield Diocese purchased land on the east side of Springfield Street for $25,000. The property, purchased from Elizabeth Stebbins, consisted of a large house of 15 rooms located on 7 acres of beautiful land in an elegant neighborhood.

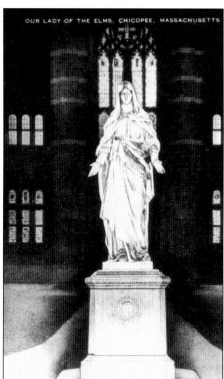

Diocesan historian Rev. John J. McCoy was invited by the bishop to select a suitable name for the academy. He called it Our Lady of the Elms because *Chicopee* in the language of the Nipmuck Indians meant "river of elms." Perhaps the academy was shaded by magnificent elm trees as well.

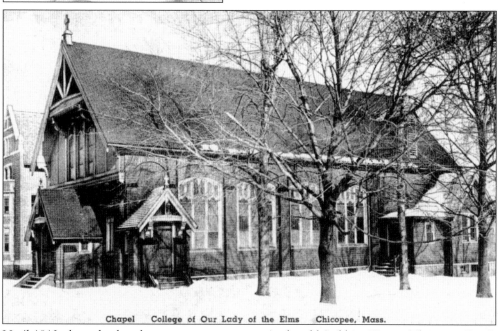

Chapel College of Our Lady of the Elms Chicopee, Mass.

Until 1913, the only chapel on campus was a room in the old Stebbins House. That year, Denis Murphy, a Chicopee contractor and the city's first Irish-American mayor, constructed a new chapel in the center of the campus. In 1993, the building was moved to a new location on the south side of the campus. The move was made to allow for the construction of a $3.6-million campus athletic center.

Named in honor of Bishop Thomas O'Leary, this large residence hall for students was the first building of the new college. The building could accommodate more than 200 students in the dormitory and dining hall.

O'Leary Hall was designed by architect John W. Donohue. The building is in the late Gothic Revival style, which was widely used for educational buildings in the 1920s.

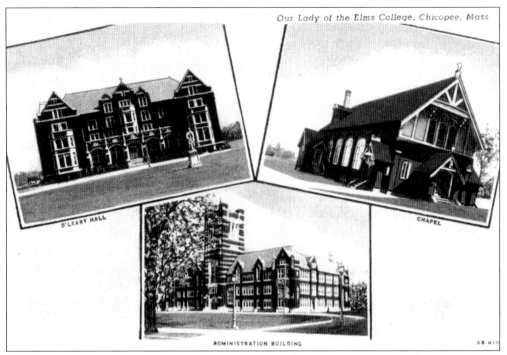

This popular postcard illustrates the three most memorable landmarks on the Chicopee campus. For many years it was the bestseller in the campus bookstore.

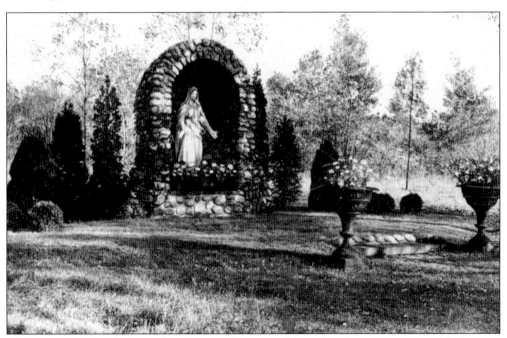

This vintage postcard shows the Grotto—for generations of students, a very special place on campus for contemplation and reflection. The shrine to Our Lady of the Elms is still in its original location. Today, it is surrounded by the athletic fields where the Elms College Blazers compete against teams from all over New England.

Silas Mosman was employed at the Ames Sword Company in Cabotville. Ames was the first bronze foundry in the United States. At the foundry in 1868, Mosman cast the bronze doors for the East Wing (Senate Chambers) of the Capitol in Washington, D.C. In Chicopee in 1906, his son Melzar H. Mosman cast the doors for the West Wing (House of Representatives). The 1906 doors are depicted in this vintage postcard.

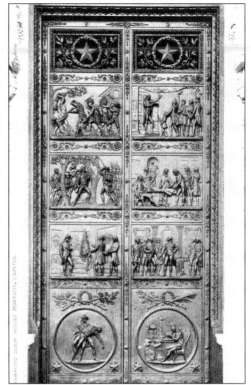

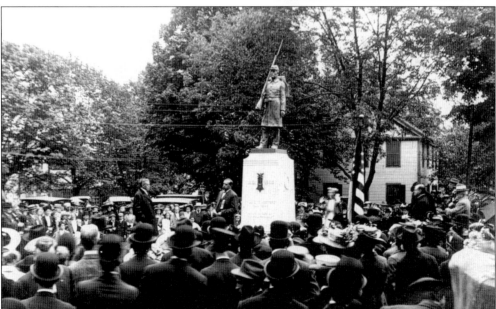

Melzar H. Mosman served with the 46th Massachusetts Volunteers in the Civil War. Following the war, the bulk of his work served to immortalize the commitment and sacrifice of the Boys of '61, who saved the republic. In this postcard, a huge crowd attends the dedication ceremonies for the Soldiers' Monument in the center of Westfield. The soldier in Mosman's statue was modeled after Capt. Andrew Campbell of Westfield.

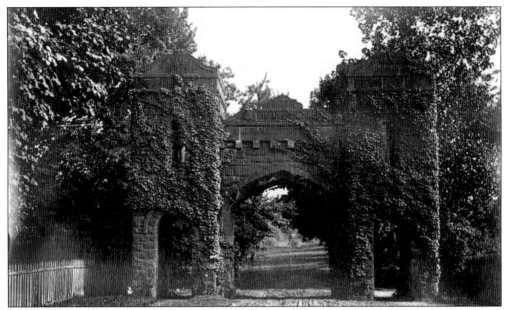

The gateway at Fairview Cemetery was designed by Melzar H. Mosman and built by the Muir Brothers Company of Somers, Connecticut. The arch is a modified Roman style; it has two semicircular openings for passage at the sides and a lancet in the center for carriages. The arch was the result of a bequest from the estate of George M. Stearns, a well-known local attorney and civic leader.

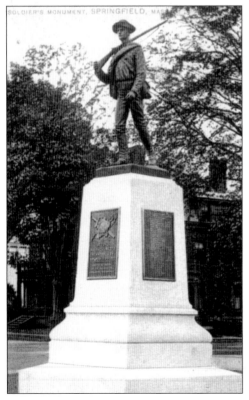

The 2nd Regiment Memorial was unveiled during a ceremony on October 25, 1906, four years after the Spanish-American War had officially ended. The memorial, erected in Springfield's Memorial Square, was considered by Mosman to be his finest work. The Springfield Union described it as "a figure of an infantry-man on the march carrying full battle equipment. In this one work, the Chicopee sculptor declared he found enough satisfaction from the fruits of his labors to fill his cup."

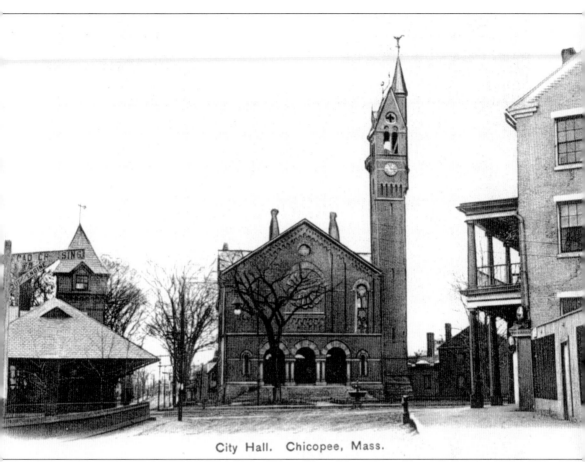

City Hall. Chicopee, Mass.

Market Square, located at the junction of four streets, is to this day the center of Cabotville. The Connecticut Valley Railroad Station, the town hall, and Cabot House are featured in this postcard. Cabot House is the oldest building in the town center; it was built by Chester Chapin on land he purchased from the Springfield Canal Company in 1834.

CHICOPEE
MASS.

A CORNER OF THE SQUARE.

This view looks north from the corner of the square. In the 1880s, the depot operated by the Boston & Maine Railroad became the Robinson Station. It seems that when Chicopee's George Dexter Robinson was governor of Massachusetts, special trains were dispatched to the Market Square Station.

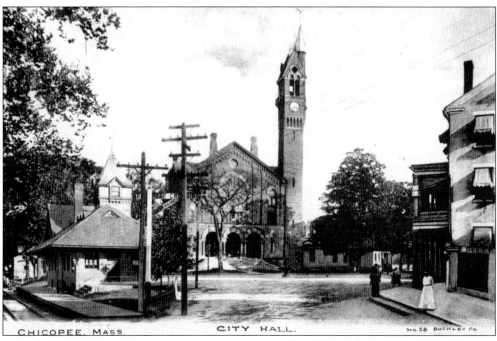

CHICOPEE, MASS. CITY HALL. No. 58 BUCKLEY Co.

According to a newspaper account, on December 22, 1871, "Soon after one o'clock the invited guests began to gather in the parlors of the Cabot House, preparatory to marching to the new hall. Only a short time elapsed before the house was full and word was given for music and the march. Gilmore's band headed the procession and following them came the Phillip's guard in all the bright array of holiday uniforms and burnished muskets." The account added that the new building was the largest town hall in Massachusetts.

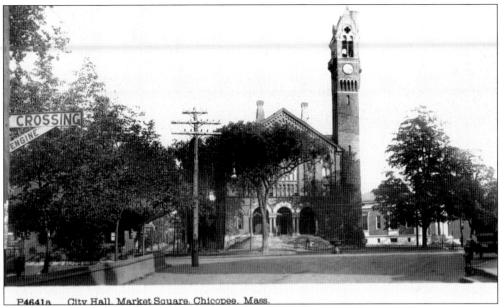

P4641a City Hall, Market Square, Chicopee, Mass.

By 1913, Chicopee's most prominent 19th-century building was called the city hall. The structure, designed by Charles B. Parker of Boston, is believed by many to be a copy of the city hall in Florence, Italy, but the resemblance is, in fact, very slight. Kristin O'Connell, in her book *The Architectural History of Chicopee*, comments that "The architect obviously felt free to adapt whatever precedents came to hand to achieve the effects he wanted without regard for consistency." She writes that the overall form is not based on civic buildings of the past, but on churches.

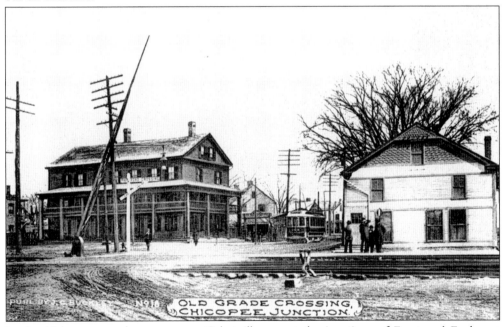

In the 19th century, the gateway to Cabotville was at the junctions of Front and Exchange Streets. The Chicopee House, shown in this J. C. Buckley postcard, was built in 1842 by Abner B. Abbey, who developed a number of Chicopee Center streets near the depot.

103

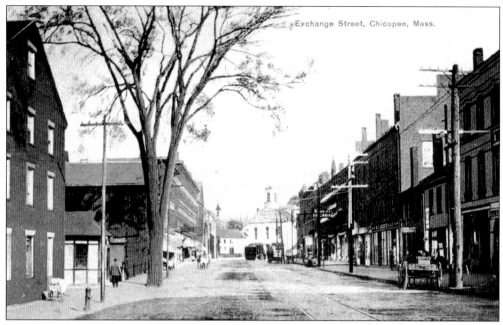

In this view, looking south on Exchange Street *c.* 1900, the United Presbyterian Church is a prominent feature. Automobiles were rarely seen, as the traffic was limited mainly to street railway trolleys and horse-drawn carts and carriages.

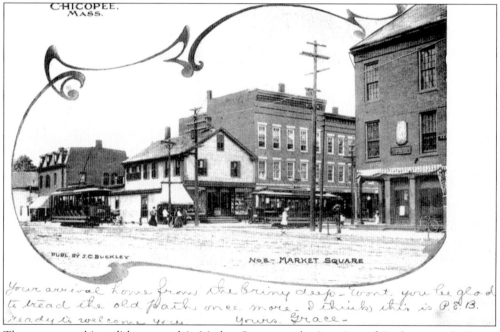

The scene on this stylish postcard is Market Square at the junction of Exchange and Center Streets. The wooden building on the corner was occupied by the Great Atlantic & Pacific Tea Company. The two trolley cars represent the two companies that operated in Chicopee. The Springfield Street Railway and the Holyoke Street Railway met in Market Square. The city had no trolley system of its own.

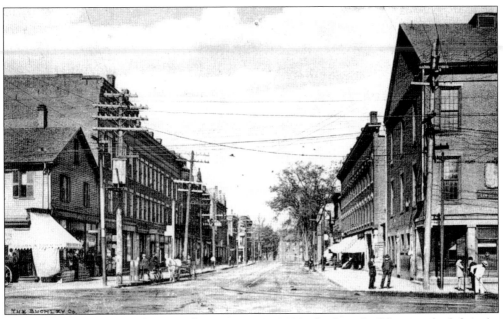

In this view, looking north on Exchange Street in 1911, the large building on the left is the Masonic Temple, built in 1848. Down the street, the building with the three large chimneys is the New Columbian Hotel. The hotel featured steam heat and was advertised as a commercial man's house.

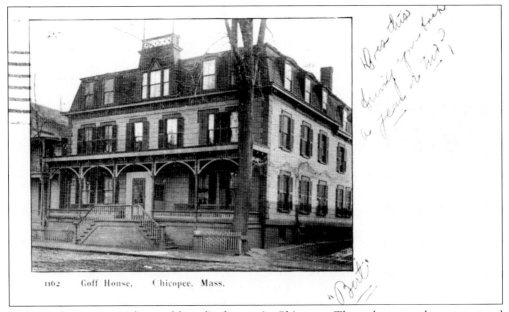

1162 Goff House, Chicopee, Mass.

In 1912, there were 10 licensed boardinghouses in Chicopee. The only one to have a postcard was the handsome Goff House, which was located at 51 Cabot Street.

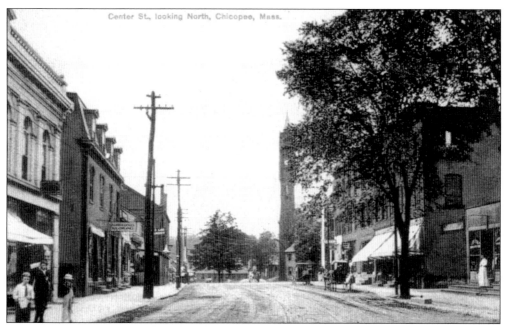

This *c.* 1908 postcard provides a Center Street view of Market Square. The building on the right is still standing today. In 1908, Paul P. Starzyk operated his very successful clothing business on the site. He advertised as a "head to foot outfitter" and called his store "the house that satisfies."

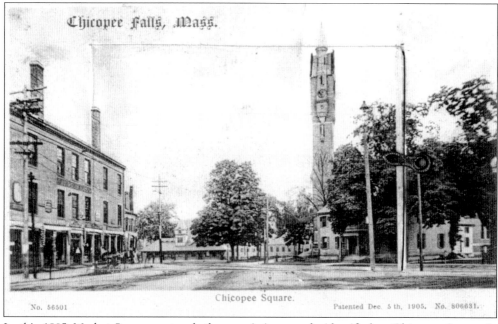

In this 1905 Market Square postcard, the area is incorrectly identified as Chicopee Square in Chicopee Falls. Three of the prominent buildings in the square, the Gaylord-Kendall Building, the Railroad Depot, and the Wells Homestead, were demolished in the early years of the 20th century.

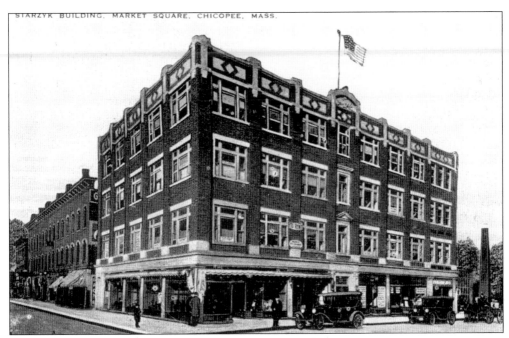

The success of Paul Starzyk's clothing business made expansion necessary, so the immigrant entrepreneur moved his business across the street. In 1920, he demolished the nearly century-old Gaylord-Kendall building, replacing it with a modern four-story structure. The Starzyk Building, on the corner of Exchange and Center Streets, remains a symbol of immigrant progress in old Cabotville.

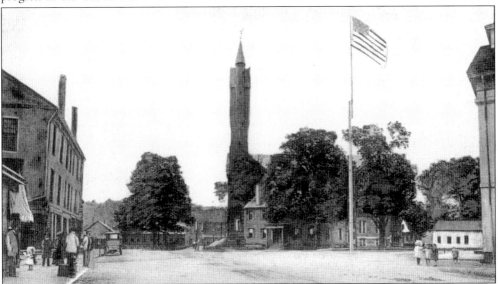

On May 14, 1853, a reading and social club called the Cabot Institute (housed in the building on the left) conveyed its library of 900 books to the town of Chicopee. At first, the use of the library cost patrons 50¢ a year. The institute librarian, a Mr. Childs, served the town library as its official head, and the books remained in the rooms of the institute in the old Cabot Hall. In 1864, George V. Wheelock, a printer, was appointed, becoming the first official town and city librarian. He served from 1857 to 1864.

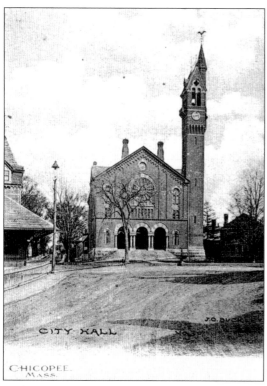

In January 1972, a month after the dedication of the new town hall, the library moved into a spacious section of the new building. The new facility was a well-lighted set of rooms with six alcoves, ample shelving for reference books, and a gallery all around. The library housed the congressional record and official state documents.

In 1891, Chicopee became a city, and the rooms in the city hall were needed for the new board of aldermen. That same year, the city purchased the Jerome Wells Homestead, adjacent to the city hall, to serve as the library's new home. Its memorable feature was a luxurious vine of wisteria that covered the back of the building, providing a sort of purple glory for several weeks of the year. Librarian George Wheelock died in office, having served the city for more than 30 years. In March of 1898, the library trustees announced the appointment of Anne Alcott "Betsy" Smith as the new city librarian.

Betsy Smith, in her quiet, unassuming way, lobbied for a new facility. Her good friends Sarah and Justin Spalding provided a generous bequest of $20,000 for a library building. Additional donations from the Gaylord and Pease families raised the necessary $47,000 for a new library in Market Square.

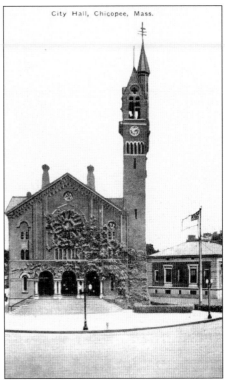

City Hall, Chicopee, Mass.

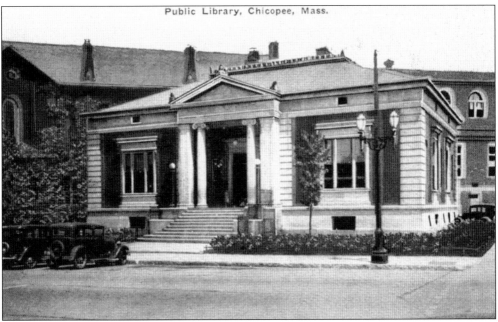

Public Library, Chicopee, Mass.

On May 31, 1913, N. P. Ames Carter, the chairman of the building commission, handed the keys to the new library to Betsy Smith. Shown in this 1930s postcard, the impressive facility was a credit to the efforts of this self-effacing young woman. She retired on March 1, 1938, two months shy of reaching 40 years of service. The newspaper noted that her public service career was the longest of any city official.

In the center of this postcard is the ornate Italianate home of Cabotville dry goods merchant Isaac Bullins. Located on a triangular lot, the house is set back from the street on an open grassy area surrounded by a simple rail fence.

In 1903, the Bullins House and the adjacent lot were acquired by the Assumption Church for its convent and school. As shown in this postcard, the house was attached to a new two-story school building on Center Street. In 1936, the parish sold the property to make way for a new Chicopee post office.

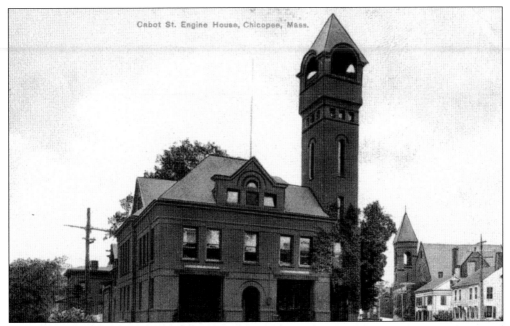

The Cabot Street fire barn was built in 1892 on the site of the old Unitarian church. In this J. C. Buckley postcard, the steeple of the Central Baptist Church is visible. In the 1930s, the Central Baptist Church, located at the corner of Cabot and School Streets, was converted into the Victoria Movie Theatre.

This F. M. Gilbert postcard features the intrepid Cabot Street Fire Brigade that saved Chicopee's city hall after a plumber's blowpipe set the roof of the building on fire. On that day in 1910, several hundred spectators filled Market Square to watch the daring firefighters do their jobs.

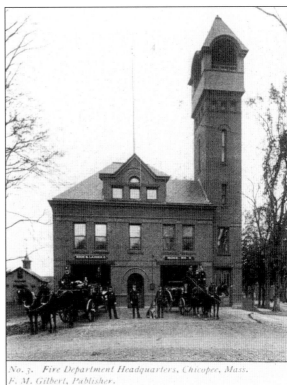

No. 3. Fire Department Headquarters, Chicopee, Mass.
F. M. Gilbert, Publisher.

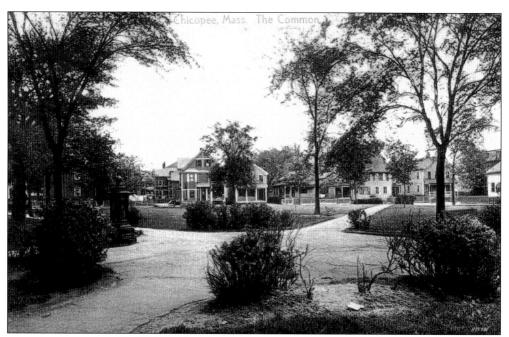

This view of Cabotville Common is from the corner of School and Chestnut Streets. The site was a grazing ground before the Revolutionary War. In line with traditional New England practice, the common was an open lot belonging to the entire community. In 1890, it became the new city's first park, featuring walks, benches, and fencing.

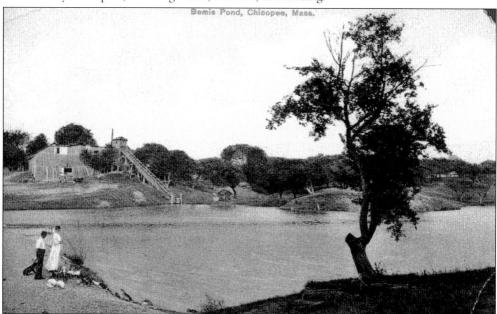

The Bemis Estate consisted of approximately 400 acres extending from Academy Street as far as Broadway into Chicopee Falls and from Front Street to the southwest at Fairview Cemetery. For many years, the Bemis family operated several highly successful apple orchards and even exported fruit to England. Pictured here, the old icehouse is in full operation. It was the main source of income for the Bemis family for many years.

Four

WILLIMANSETT

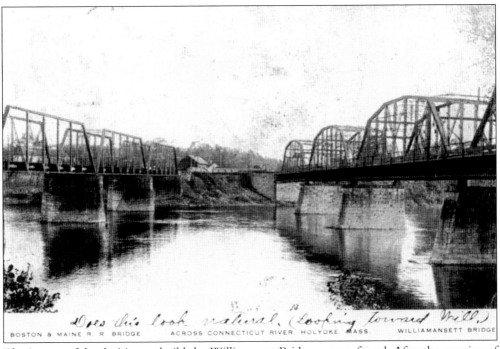

The impact of the decision to build the Willimansett Bridge was profound. After the opening of the new span in 1893, Willimansett developed close ties to Holyoke; even postal and telephone service was tied to the "Paper City."

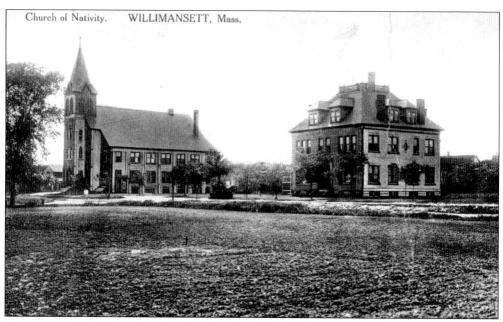

In this classic postcard, the Church of the Nativity of the Virgin Mary and its large parish house seem to be in an undeveloped area. That observation is not far from the truth. The parish, located at the corner of Chicopee and Newton Streets, is in the center of the Willimansett section of the city. After the completion of the Willimansett-Holyoke bridge in 1893, the population of the area skyrocketed with the arrival of French Canadian immigrants. They settled in Chicopee, taking the trolley to their jobs across the bridge in Holyoke.

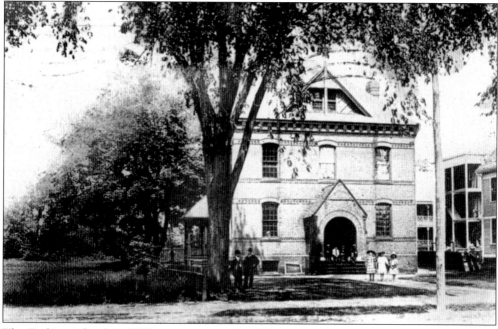

The Perkins School in Willimansett was built 125 years ago. For a brief time it served as a restaurant, and today it houses a day-care facility. It is one of the few remaining high Victorian Gothic buildings in the city.

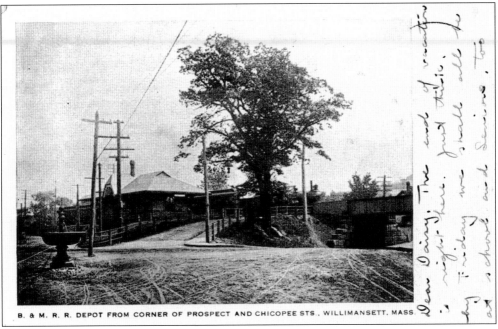

B. & M. R. R. DEPOT FROM CORNER OF PROSPECT AND CHICOPEE STS., WILLIMANSETT, MASS.

The Boston & Maine Railroad Station in Willimansett was on the main line to White River Junction, Vermont. In 1842, the Connecticut River Railroad ran a line from Chicopee Junction north through Willimansett and across a trestle bridge into Holyoke. In 1922, the elevated track bed served as a dike, saving Willimansett during a flood.

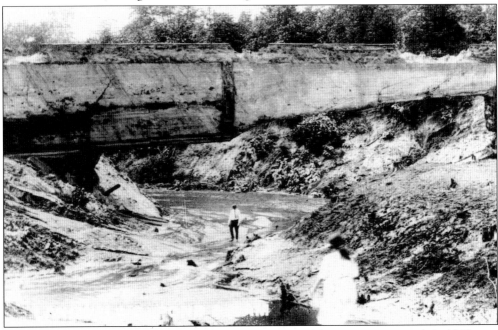

Old-timers recall the summer the summer of 1922 as one of the rainiest on record. In 1900, two dams were constructed on the Willimansett Brook. On the upper brook in Fairview, the dam at Langwald's Pond was a popular swimming hole. At approximately 2:00 a.m. on July 17, 1922, the upper dam burst, sending a 20-foot wave down the Willimansett Brook into Roberts Pond.

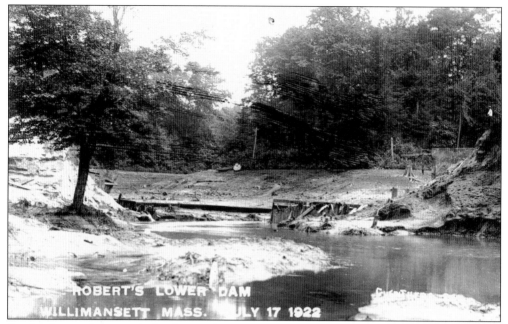

At the lower dam on Robert's Pond, A. H. Langwald operated an icehouse. Residents of the Pleasantdale section of Willimansett reported hearing a thunderous roar followed by an ear-shattering crash as the second dam collapsed.

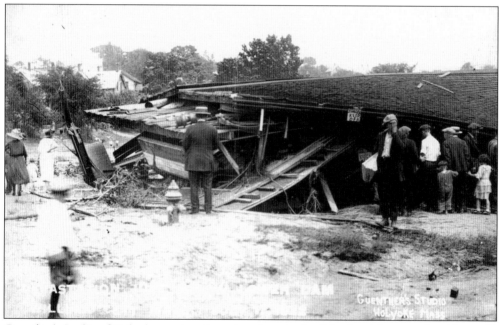

Guenther's Studio of Holyoke produced a series of postcards of the flood damage. A resident told the *Springfield Union,* "I was awakened by the sound of splashing waters, I looked out, and was impressed by flashes like lightening, which came from the broken electric wires. It seemed like the end of the world was at hand."

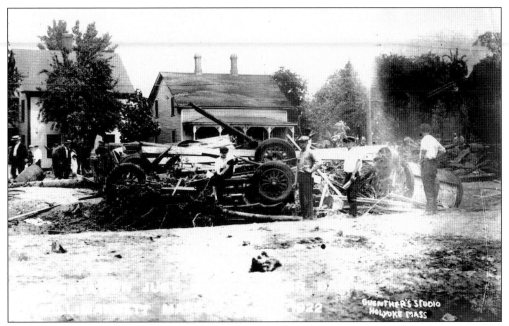

The noise made by the rushing waters that coursed down the narrow valley of the Willimansett Brook and spread out in the lowlands above the Boston & Maine Railroad Station was compared to thunder by the people on the high ground. This postcard shows residents surveying the damage near Roberts Pond.

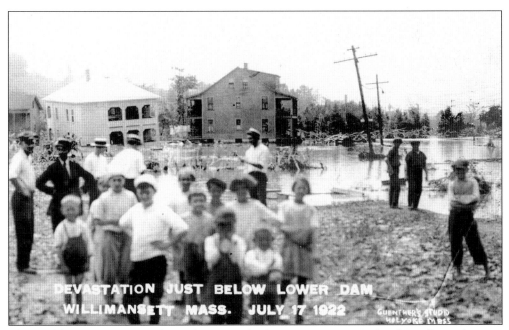

Pleasantdale youngsters pose for Walter Guenther's camera on an inundated Pendleton Avenue. Massive amounts of water had backed up into Massachusetts, Ohio, and Pennsylvania Avenues.

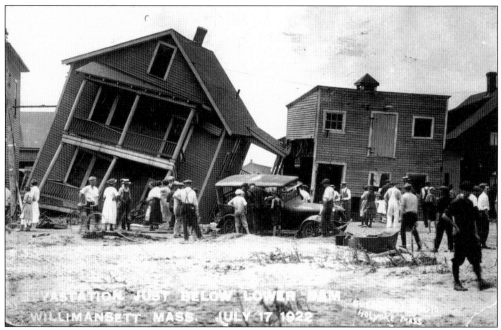

The flood waters undermined buildings on Ohio Avenue. Chicopee mayor Joseph Grise said that he was going to fix responsibility for the disaster. He added that he was out to get the negligent parties and see what could be done to repair the damage. For the most part, the residents of Pleasantdale, who had survived a night of hell, were happy to be alive.

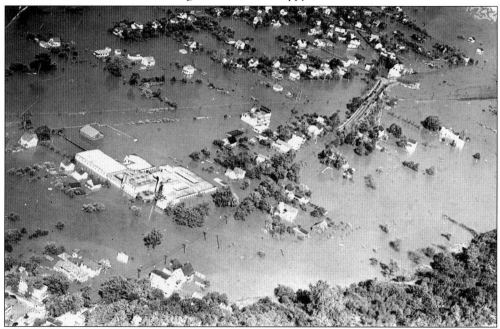

In 1936, the Willimansett area was completely inundated by the biggest flood in the city's history. The Dana S. Courtney Bobbin Shop is the large wooden factory in the center of the postcard. Following another serious flood in 1938, the U.S. Army Corps of Engineers constructed a series of dikes along the Connecticut River.

Five

WESTOVER

On September 19, 1939, Mayor Anthony J. Stonina received a letter from the U.S. War Department. The letter stated, "You are advised that the Secretary of War has approved and authorized the acquisition of approximately 5,000 acres of land located northeast of Chicopee, Massachusetts, for the site of the Northeast Air Base."

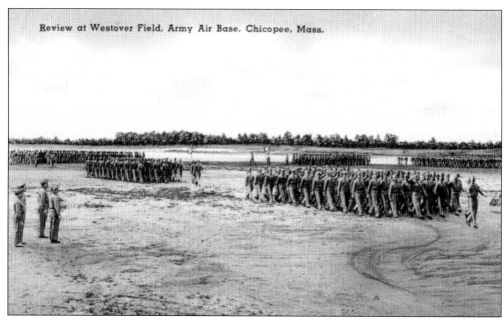

Review at Westover Field, Army Air Base, Chicopee, Mass.

In 1937, when Chicopee learned of plans to establish a northeast air base, the local business community, led by Dr. John F. Kennedy, supported Mayor Anthony Stonnia's drive to persuade the War Department to locate the base on the tobacco plains of western Massachusetts. The new base was dedicated in April 1940 and named for Maj. Gen. Oscar Westover.

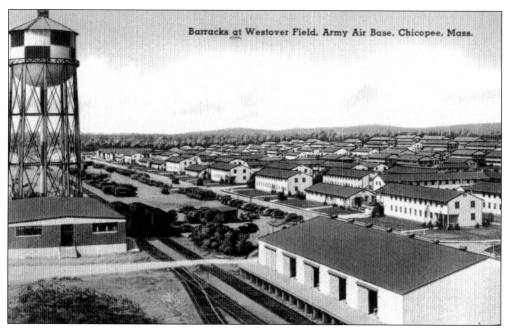

Barracks at Westover Field, Army Air Base, Chicopee, Mass.

Frank Faulkner, in his book *Westover: Man, Base and Mission*, reports that the first B-24 Liberator airplanes arrived at Westover in November 1941 for antisubmarine missions to protect convoys carrying supplies to Britain. By September 1943, the U.S. Navy had ample crews for the antisubmarine mission and Westover's B-24 crews were quickly trained for high-altitude bombing.

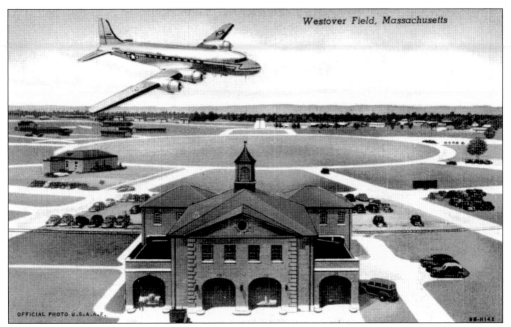

A C-47 is pictured flying over the base's main fire station. These planes were first assigned to the base in 1943 as part of the Troop Carrier Command. Pilots were trained to tow Waco gliders, which were to be used in the invasion of Europe in 1944. By the end of the war, more than 2,000 air crews for B-17s, B-24s and B-26s had been trained at Westover.

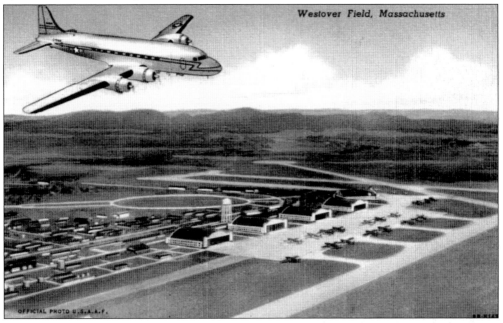

Following World War II, the C-47s stayed at the base as part of the Military Air Transport Command. On June 24, 1948, the Soviet Union blockaded all land routes into Berlin. What was to become the world-famous Operation Vittles began on June 27, 1948. Westover Air Force Base became the U.S. hub for overseas flights in support of the air bridge, keeping the free sector of Berlin from Soviet occupation.

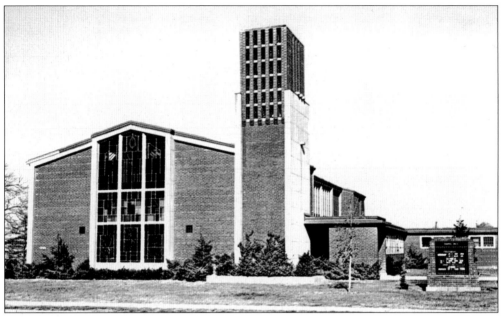

In the 1950s, a U.S. Air Force regional hospital was opened and a handsome new chapel with a distinctive bell tower was constructed. In 1956, the Military Air Transport Service left and was replaced by the Strategic Air Command.

The first B-52 of the 99th Bombardment Wing arrived at Westover in September 1956. In the late 1960s, the B-52s went to war in Vietnam. Used as tactical bombers with conventional iron bombs, they were sent to Southeast Asian bases on six-month tours.

The base was turned over to the U.S. Air Force Reserve in 1974. The era of the C-5 Galaxy, the largest aircraft in the air force inventory, began at Westover in 1987 with the arrival of 16 massive planes. Westover celebrated a half-century of flying in July 1990, attracting close to 750,000 visitors to the 50th Anniversary Air Show.

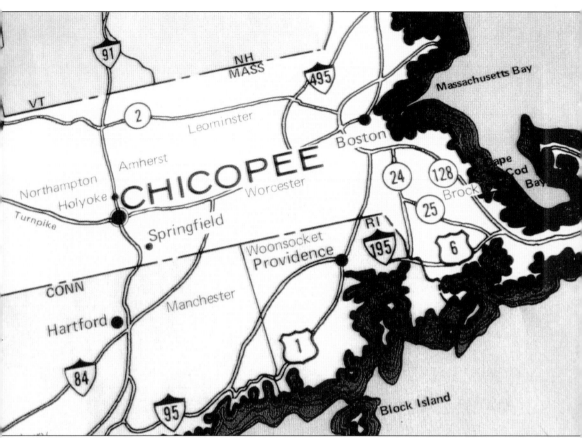

In the 1950s, the expansion of Westover made Chicopee the "City with Wings." The city soared economically, as its location near the junction of the Massachusetts Turnpike (Interstate 90) and Interstate 91 placed it at the transportation crossroads of New England.

Six

THE TURNPIKE

On May 15, 1957, Gov. Foster Furcolo officially opened the 123-mile Massachusetts Turnpike. The governor, whose home was in Longmeadow, viewed the new highway as an immense boost for the future development of western Massachusetts. He said it would "tie the two ends of the Commonwealth together more tightly than ever before."

Start the Day Right with Ed Carter!

7:15 to 9 A.M. **WACE** **730 on Your Dial**

This unique postcard features Ed Carter, who was the morning voice of Chicopee radio station WACE in the 1950s. His real name was Edward Zych, and he was a World War II army veteran whose family owned Zych's Market on East Street. For 17 years, the citizens of Chicopee tuned to 730 AM, starting their day right with Ed Carter.

COOK MOTOR SALES, INC.
Chicopee, Mass.

The explosion in the popularity of the automobile in the 1950s is vividly illustrated in this postcard. The Kuchta family closed the famous City Hall Garage in Market Square and purchased the Robert Bemis property on Front Street. The old Bemis Homestead towers over the new showroom and a sea of automobiles.

A Boston company with roots in the state's industrial past purchased a 128-acre tract of land already zoned for industry. The tract was located at the northwest corner of the intersection of the new superhighway and the Springfield connection at Exit 6. The Cabot, Cabot, and Forbes project was called the Massachusetts Industrial Park in Chicopee.

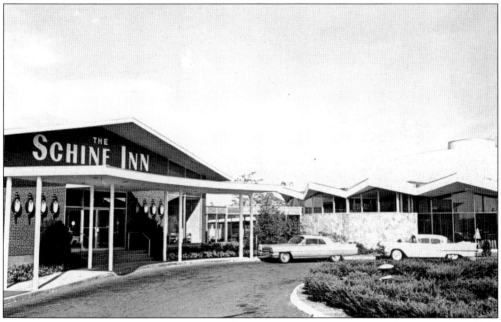

In 1957, the state completed the new Massachusetts Turnpike, and Exits 5 and 6 on the new road were primed for development. Westover was now headquarters for the fabled 8th Air Force of the Strategic Air Command. The following year, at the junction of the turnpike at Exit 6, a new world-class hotel was constructed by the Schine Hotel chain.

Chicopee's New Comprehensive High School

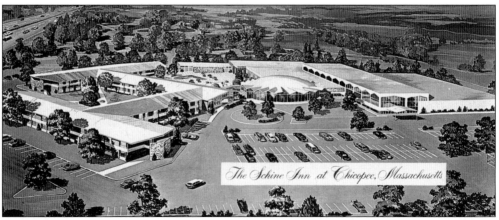

The new Chicopee Comprehensive High School opened on Rolfe Avenue in 1962. The three-story structure was described as one of the most magnificent and utilitarian educational facilities in the world of academia. Built and equipped at a cost of $2.4 million, the beautiful edifice is designed with 69 classrooms to accommodate a maximum enrollment of 1,800 students.

The Schine Inn at Chicopee, Massachusetts

In this promotional postcard, the Schine Inn is a very impressive facility. The circular building in the center of the complex is the Phineus Fogg Ballroom, decorated with memorabilia from the Academy Award–winning movie *Around the World in 80 Days*. In October 1962, the room was host to Charter Night, a spiffy black-tie affair that celebrated the establishment of the Chicopee Chamber of Commerce.

Library